watercolour

foundation course

watercolour

Curtis Tappenden

CASSELL ILLUSTRATED

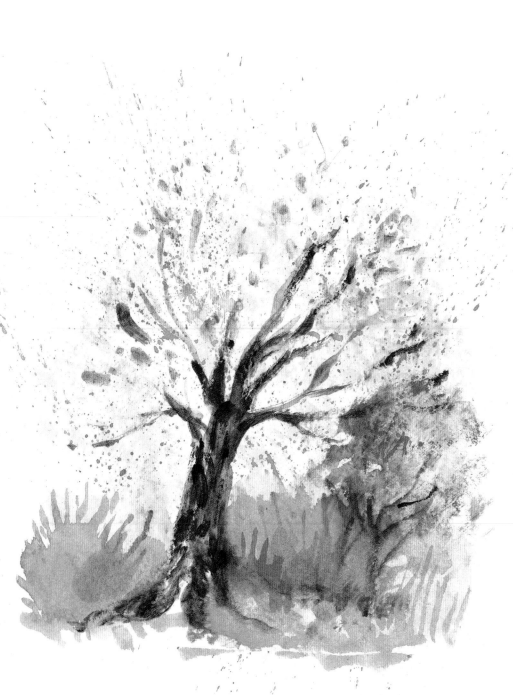

First published in Great Britain in 2003 by Cassell Illustrated
a division of Octopus Publishing Group Ltd.
2–4 Heron Quays, London E14 4JP.

Text and design © 2003 Octopus Publishing Group Ltd.
Illustrations © 2003 Curtis Tappenden.

Series development, editorial, design and layouts by
Essential Works Ltd.

Distributed in the United States of America by
Sterling Publishing Co., Inc.,
387 Park Avenue South, New York, NY 10016-8810.

A CIP catalogue record for this book is available from
the British Library.

ISBN 1 84403 082 2

Printed in China

Contents

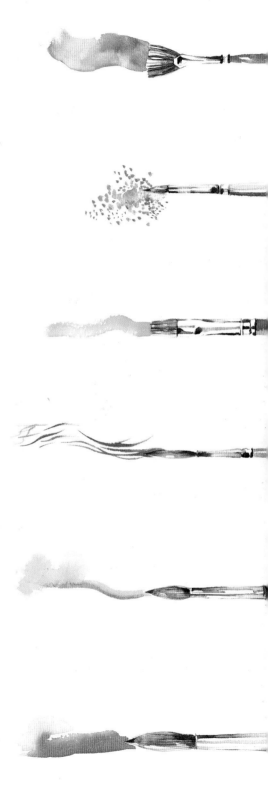

Introduction

For immediacy of use and freshness in execution, no artistic medium can match that of watercolour. It offers a wide range of possibilities to the eager beginner and satisfied expert, alluring them both to explore its great contrasts and contradictions – being perhaps the hardest medium to master, while at the same time holding the simplest basic techniques. The key to enjoyable, satisfying watercolour painting remains in its simplicity. Those who try too hard to control and manipulate its natural properties, even to the point of using it as they would oil or acrylic paint, so often find themselves left with dull, muddy studies, heavily laboured in layers of thick paint where no light can reflect through bright, translucent stains of pure colour. Disappointed with their failing efforts, they give up. This book sets out to present watercolour as a valid medium for 'all' who wish to courageously dabble with its irresistibly charming character, and develop in their own time ways of personal application to suit their needs as creative picture makers.

The first section is devoted to introducing relevant tools and materials, offering sound advice on their necessity and usage. Techniques form the next part of the book, and each is illustrated in depth with easy-to-follow captions and annotations to guide you through to proficiency and a full understanding of your newly acquired repertoire.

With the basics in place you will be ready to enter the 'Masterclasses' with full step-by-step instruction based upon popular painters' themes. From the planning stage to full completion, you will be shown the best approaches to various subjects and given, first hand, all the tips and tricks of the trade.

A special feature of this book is its frequently placed 'recap' sections, which provide you with the opportunity to assess your own development and consider some of the areas you might like to improve upon. No artist is ever perfect and even the most competent practitioners of watercolour make mistakes. Errors are more common then you might think, but here they are honestly discussed, with rescue solutions offered where appropriate. When you are ready to accept the challenge, pick up your brushes and palette and get painting!

A history of watercolour

Beginnings

It is sometimes thought that the practice of watercolour painting began in the eighteenth century at a time when its popularity, especially in Britain, was reaching new heights, but this is not strictly true. The Cave painters of Lascaux and Altamira had ground their earthy soils and charred wood stumps to form the pigment used to depict their beasts long before anyone had considered the invention of an artistic medium. Soft, harmonious, water-based colours had already been laid onto the surfaces of tombs by the ancient Egyptians of 4500BC and distemper, fresco and tempera, commonly used from the times of the Romans through the fifteenth century Renaissance, all have water as a base ingredient. Watercolour, as we know it today, constitutes fine ground pigments of various sources, which are mixed with the extract of a Senegalese acacia tree, known as Gum Arabic. This acts as a varnish, brightener and binder. The medieval manuscript illustrators added white chalky pigment which created another new medium – gouache, ideal for providing the perfect opaque base for the application of gold leaf. The first evidence of transparent colours being laid on paper to produce atmospheric landscapes was produced by the German Renaissance master Albrecht Dürer (1471–1528) and his woodland series of the late 1490s have an extraordinarily contemporary feel to them.

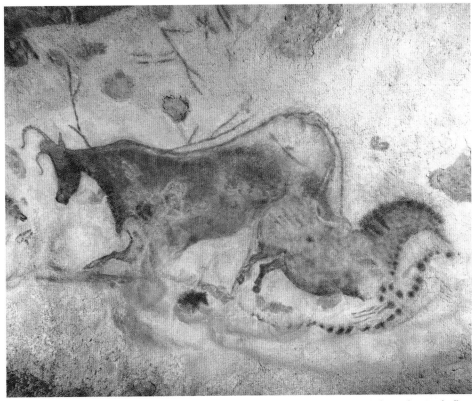

The natural ochre palette of red, brown and yellow was a perfect and accessible medium for use by cave dwellers.

When Sir Walter Raleigh set sail for the shores of North America, he took with him John White, a reputable draughtsman of his day, to record scenes of life around what we now call North Carolina. The skill and simplicity he demonstrated with clean, fluid washes has led some historians to name him as the founder of the 'English School', as it later became known on the Continent. This is not to say that the intervening centuries were periods of inactivity in the new medium. The French classical landscape artists Nicolas Poussin (1594–1665) and Claude Lorrain (1600–82) made studies using a combination of pen, ink and monochromatic wash that were to influence the manner and techniques of later watercolour painters.

Eighteenth century

For the first time in its history, artists named the new medium and chose to concentrate specifically on developing its properties. By the mid-eighteenth century, the English Watercolour School was born. Paul Sandby (1725–1809) exploited its transparent and opaque qualities, while Alexander Cozens (1717–86) gloried in the simplicity watercolour had to offer, by painting fresh, economical studies from nature. His son, John Robert Cozens (1752–97), took bolder steps forward and discovered how to paint landscapes of scale and intensity with powerfully atmospheric washes of strong earth browns contrasting against airy films of green and blue in the sea and sky. This fusion led J.M.W. Turner (1775–1851) and Thomas Girtin (1775–1802) to forge ahead with great experimental creativity and firmly stamp a seal of authority onto watercolour as a medium in its own right, not just a convenient way of making quick preliminary sketches for final oil paintings. It was Girtin who realized the effect that textured papers could have on various brush marks and when he deliberately coupled them with a reduced palette of just a few colours he achieved astoundingly accomplished and technically adept paintings.

Turner and beyond

Way ahead of his time, the energetic, compulsive Turner took the medium where no one had so far dared to go. Testing every conceivable paper, he scratched, scrubbed and

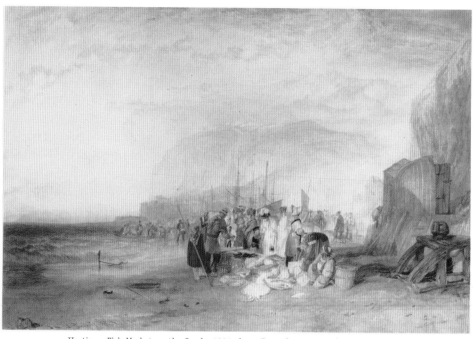

Hastings: Fish Market on the Sands, 1824 *shows Turner's preoccupation with delicate, translucent light which typically fills three-quarters of the composition, and adds a sense of calm to the busy scene.*

rubbed the surface before flooding it with liquid colour and, working wet-in-wet, produced semi-abstract masterpieces that were shunned by the artistic establishment.

Another significant contemporary of Turner was John Constable (1776–1837) who used watercolour to capture the fleeting movements of the clouds in the sky and the changing effects of light on the English landscape. Much freer and more immediate than his oil paintings, Constable's excitingly vigorous

approach to the medium often involved employing the textural effects of scraping and scratching to build up the depths within a painting. John Sell Cotman (1782–1842), after whose name a well-known paper is branded, painted to a different set of rules, being very careful to design his compositions with overlapping and interlocking tonal planes of more sombre and dramatic hues. The result was a body of work that at times would not look out of place in the modern scene.

A nineteenth-century progression

Further developments by artists in Britain and Europe in the mid to late nineteenth century revealed a keenness to move watercolour forward and this occurred in quite different ways. The movement of visionary artists William Blake (1757–1827) and Samuel Palmer (1805–81), who formed a group known as The Ancients, showed painting at its quirkiest. Blake devised a technique of painting onto glass and then pressing this against the paper, thereby printing a base layer. Fine detail was added using body colour and thickly mixed pigment. Palmer's pastoral celebrations were also worked up in layers of rich, textured pigment and his pictures clearly reveal the addition of opaque white for highlights as well as the removal of paint scratched back to reveal bare white paper. Abroad, things could not have contrasted more greatly. The French Impressionist Camille Pissarro (1830–1903) let brilliant, watery colours run into one another under the guidance of short, flat strokes – his choice of palette being clearly influenced by the warm Mediterranean sun. Paul Cézanne (1839–1906) did similar things, but from a more constructed angle, allowing the transparency of multiple layers to form the early cubist shapes which defined him as one of the first twentieth-century modern painters.

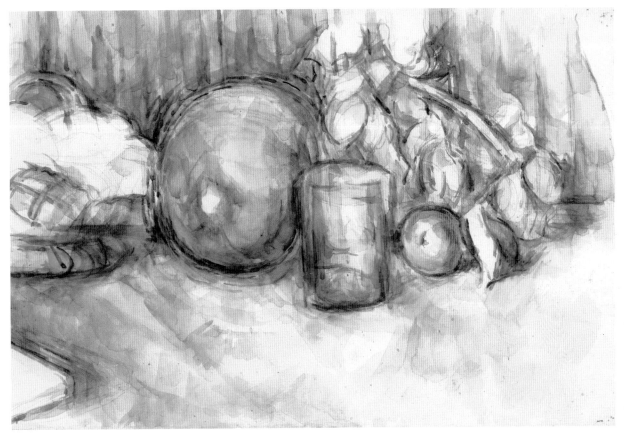

Cézanne painted Still Life with Green Melon *using strokes of complementary colour, with objects cleverly defined by the whiteness of the paper being strongly reflected from beneath the washes.*

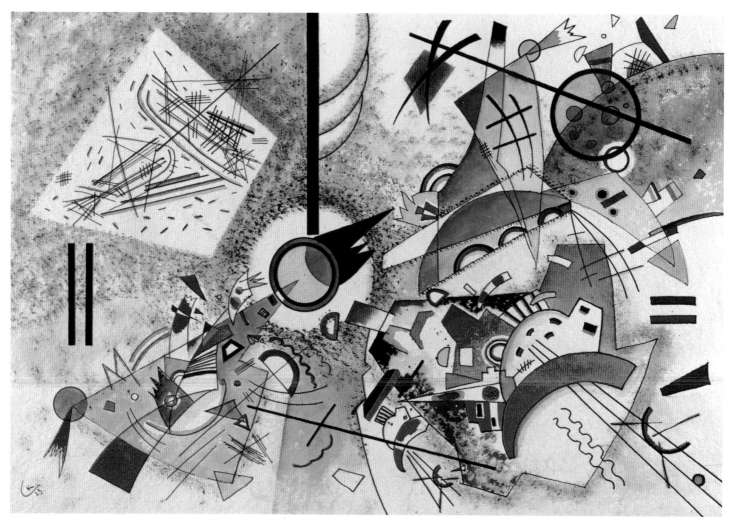

Energetic shapes of vibrant watercolour clash and collide in Kandinsky's abstract experiment of 1923.

Twentieth-century experimentation

Suddenly released into the new worlds of abstraction, Wassily Kandinsky (1866–1944) and Paul Klee (1879–1940) allowed the lyrical quality of music to influence the dance of their brushes, thereby creating a new visual language which liberated them from the former restrictions of pictorial realism. Shapes and patterns came alive in complementary combinations, and performed across the paper in thinly, decorative, liquid passages. Franz Marc (1880–1916) and August Macke (1887–1914) both delivered the power of life through direct and luminous swirls of intense colour, the former expressing himself through the sleek movements of horses and other majestic, wild beasts, and the latter through North African-influenced landscapes. The German artist Emil Nolde (1867–1956) pushed the medium to greater limits. Deep red stains of blooms wilting in a vase could evoke intense feelings of fragility and decay and his turbulent seascapes tossed raw and emotive waves of acidic yellow into bruised purple skies.

American realism

In America, too, watercolour rapidly gained in popularity during the late nineteenth century, with a style that was distinctly more realistic. Both Winslow Homer (1839–1910) and John Singer Sargent (1856–1925) captured something of the American temperament in their fluent sketches of life, paying careful attention to the details of everyday human activities against a largely isolated backdrop of sea and landscape. Edward Hopper (1882–1967) continued the theme of isolation realized in the lonely figures that populated the enigmatic urban diners and skyscraper office blocks of America's big cities. The apparent simplicity of his watercolour technique always belied the true depth of his vision and ability to set the viewer ill at ease.

Innovation and experimentation

At the beginning of the twentieth century, a new interest in the English tradition of watercolours brought a whole generation of young artists to the medium. Paul Nash was one of the leading exponents, and used dry-brush cross-hatching to emulate his other key discipline, wood engraving, and David Jones coupled the drier, lighter method with lyrical swathes of the brush.

The exquisitely fine work of Eric Ravilious followed suit with otherworldly studies of peculiarly British landscape, while his contemporaries, John Piper and the sculptor Henry Moore, experimented with texture and mark to enliven their work and push new boundaries.

Edward Burra's Approaching Storm *of 1968–69 reveals the artist's strong use of patttern and dense passages of dry colour, achieved by mixing paint with spittle.*

Now, in the twenty-first century, the medium is universally no less attractive, and boundaries are still being pushed. The invention of new water-soluble media such as PVA, acrylic and watercolour pencils has opened up wider possibilities in mixed media work, and the once accepted limitations have been broken down by new technological developments and revised practices. It is important to look back in order to move forward, but the challenge remains exciting, refreshing and at times for watercolour, so totally unpredictable.

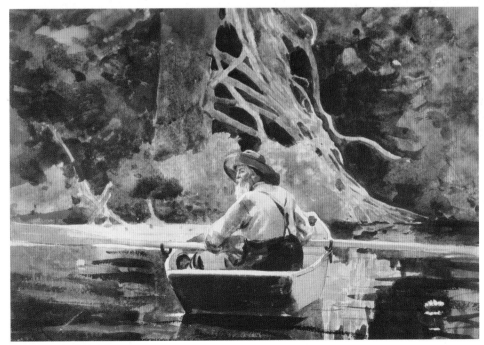

Preferring to work outside, Winslow Homer brought freshness and vitality to the American scene, powerfully juxtaposing broad strokes of deep, saturated colour with light, atmospheric colour.

Tools and Materials

Brushes

Brushes come in a variety of shapes and sizes and have been tailored over the centuries to suit a number of different practical purposes. The importance of the brushes you use cannot be underestimated, and your own visual signature is determined by them. The finest brushes are elegant, wonderfully crafted tools and it is true to say that their quality directly relates to their price. Buy the best brushes you can afford, and do not buy too many to begin with: this is the best advice that can be given to anyone who is serious about watercolour painting.

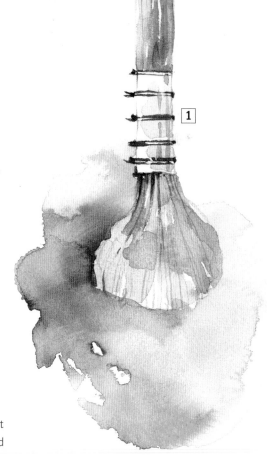

Every brush should have an ample belly of hair, the best and most expensive material being Kolinsky sable, and the cheapest made from synthetic fibres. The hair is held in place by a ferrule, made of cupro-nickel plate to prevent corrosion. A good brush should be springy, and have the ability to hold a full load of paint and to release it gently and evenly onto the paper. You should be able to bring the hairs to a fine point or well-shaped edge during use and return them to a fine point when you have finished painting.

Sable hair is obtained from the tail of the sable marten, a relative of the mink, and has a distinct reddish-brown colour. The Kolinsky sable, which provides the best-quality hair, lives in the Kolinsky region of north Siberia. With correct use and aftercare, sable brushes can last a lifetime. They have a delicacy and precision unsurpassed

by any other material and their flexible response produces lively, controlled strokes.

Squirrel hair is dark brown and very soft. It does not easily come to a point and does not last very long. Brushes made from it are best confined to the laying of large, even washes.

Goat hair is also very soft, but harder-wearing than squirrel. Traditionally used for oriental brushes, it holds large quantities of water and is excellent for laying down large wet-in-wet washes.

Ox hair is coarse and long, and is most suitable for flat-edged brushes.

Synthetic fibres are made from polyester or nylon strands and have been introduced as durable, cheap alternatives to sable. Although their quality and pigment-holding properties do not match those of sable, they are infinitely better than squirrel, their equivalent in price.

TIP

Never let brushes stand in a water pot after use, as this will cause them to lose their critical shape. Wash them out thoroughly with warm, soapy water immediately, making sure that the ferrule end is thoroughly clean. Spittle is best for reshaping brushes. Apply a little to your palm and then gently roll your brush around in it to bring it perfectly back to shape. An alternative is lathered soap, using the same method.

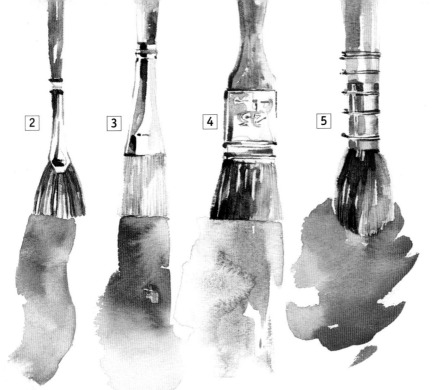

Spotter [*6*] has a short head and fine point and is a precision tool, ideal for miniaturists and botanical illustrators.

Chisel-edged flat [*7*] is like the ordinary flat brush, but more precise and easier to vary between finer strokes and broader washes.

Rigger [*8*] was originally used for fine ornamental painting on ships. The long springy hair makes it easier to control the sweep of fine lines and curves, and it is especially good for lettering.

Medium round brush [*9*] is ideal for finer, more delicate painting.

Large round brush [*10*] can be brought to a fine point for detailed work, and can also be used for broader sweeps in larger-scale painting.

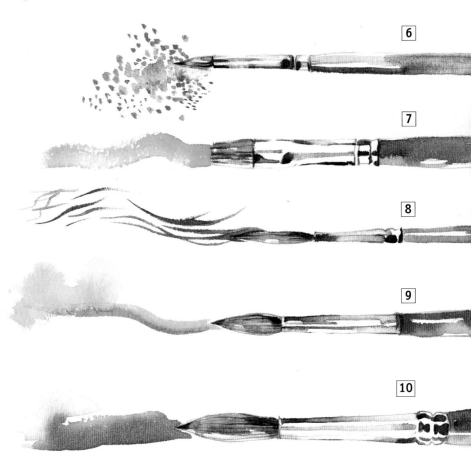

Most brushes are classified as either round or flat. Round brushes range from size 0000 to 26. They are probably the most common brush shape available and the most versatile, being equally good for delicate strokes, broader strokes and flat washes. Flat brushes are square-ended and mainly used for laying broad washes in their larger sizes, and clean, flat strokes in the smaller range.

Blender and fan brushes [*1,2*] assist the smooth running together of two colours when gently worked into wet washes.

Thick flat brush [*3*] is not unlike a wash brush, but, because it is stiffer, it can produce a well-controlled, one-stroke line. It can also be used for toning.

Wash brush [*4*] is set in a flat ferrule and can rapidly lay large washes.

Mop [*5*] has a large, round, soft head of synthetic hair to soak up a large amount of water, before flooding it over the surface.

Paints

Choosing the right paints can be daunting, but with just a little knowledge you will be able to make choices to suit your personal painting needs. Watercolour paint is basically fine-ground pigment bound with a water-soluble gum known as gum arabic, extracted from a species of acacia tree. While some pigments are derived from organic sources such as natural minerals, others are chemically produced using synthetic ingredients. All, however, are manufactured with added gum to produce colours that dilute in water, along with a little glycerine for a slightly glossy finish.

There are two grades of watercolour: 'artist's quality' and 'student's quality'. Although cheaper, student paints contain a lower proportion of pigment, and may not allow you to express the subtleties for which watercolour is renowned. It is far better to invest in a small quantity of artist's paints, adding to it as finances allow. When choosing your paints, you will also have to decide which form you prefer: cake, pan or tube. The list below outlines the characteristics and advantages of each type.

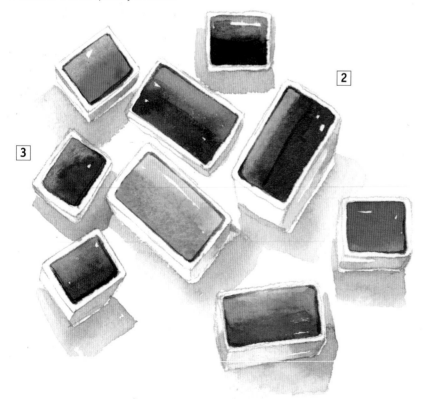

TIP

When using a tube of paint, make sure that the thread is clean before replacing the cap or it may stick fast. Running the tube under a hot tap may help, or use pliers in extreme cases.

TIP

Pans come paper- or foil-wrapped. Once opened, they tend to stick to the box lid when it is closed. Remove excess moisture from the paints with a damp sponge after use and, where possible, leave the box open for a couple of hours so that the pigments can dry naturally.

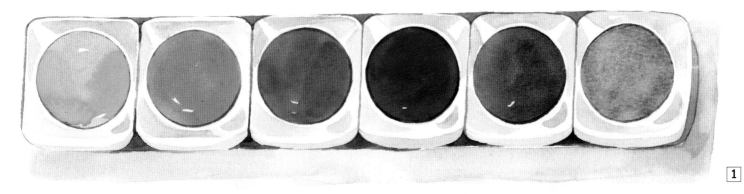

<div style="text-align: right;">1</div>

Cakes [1] are similar to those found in childrens' sets, and are the most traditional form of watercolour. Containing little glycerine, their colour is highly concentrated, and vigorous brushing is required to lift the colour from the block. Each cake should be softened with a few drops of water and left to stand for about five minutes prior to use.

Pans [2] measure 20 x 30mm (1¾ x 1¼in) and are made of porcelain or, more commonly now, hard plastic. When not in use, pigment in pans remains semi-moist, making it easier to lift when wetted. All pans have to be carried in specially made tins or boxes, which are convenient for outdoor sketching as their hinged lid doubles up as a useful mixing palette.

Half-pans [3] measure 20 x 15mm (¾ x ⅝in) – half the length of full pans – and function in exactly the same way. Because of their small size, they automatically restrict you to taking off only as much paint as you need, and are therefore economical to use. All pans and half-pans can be purchased in sets or singly (0), so that an empty pan can simply be replaced with another.

Tubes [4] of watercolour contain the most glycerine and are very soft and creamy. Because large amounts of pigment can be squeezed out all at once, tubes allow for larger-scale painting. Working this way, however, does mean that you will have to decide which colours you need before you start, and the paint may dry and harden before it is all used. Tubes, therefore, can be more wasteful than pans. Paint may also leak and if the cap is left off, the pigment will dry out, rendering it useless. Old tubes may need

to be replaced as they are prone to their ingredients separating if not used for a long time. There are three variations of tube size: 5ml, 15ml (the standard size), and 20ml.

Gouache [5] an opaque version of watercolour, also comes in tubes. It is basically a dense pigment with matt, covering qualities. Sometimes it is manufactured with added Chinese white, or chalk. It can be applied in layers as solid or translucent colour, depending on how much it is diluted. Because larger quantities are required to give coverage, standard size tubes are 20ml.

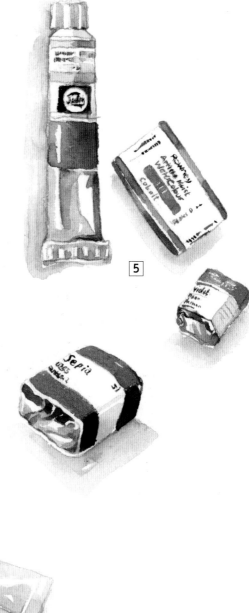

Other media

Watercolour's ability to cover large areas rapidly with layers of transparent colour makes it the ideal companion of other media. Virtually any dry or water-based medium can be used in conjunction with watercolour to produce some full-bodied and stunning effects. Once you know what is available, you can begin to experiment with different combinations.

TIP

Beware of using inks in a painting that will be exposed to long periods of daylight. Most inks are fugitive (not light-fast) and will gradually fade away in natural light.

Watercolour pencils [1] *make much the same marks as any other carbon pencils, but, the moment water is added, they burst into life, intensifying in hue and bleeding dramatically. They can be applied dry, or wet with a brush, sponge or even a finger. Dry washes can be worked over in greater detail, and further washes applied. Available in sets or sold individually, their facility for allowing tightly controlled work or looser washes makes watercolour pencils an attractively flexible medium.*

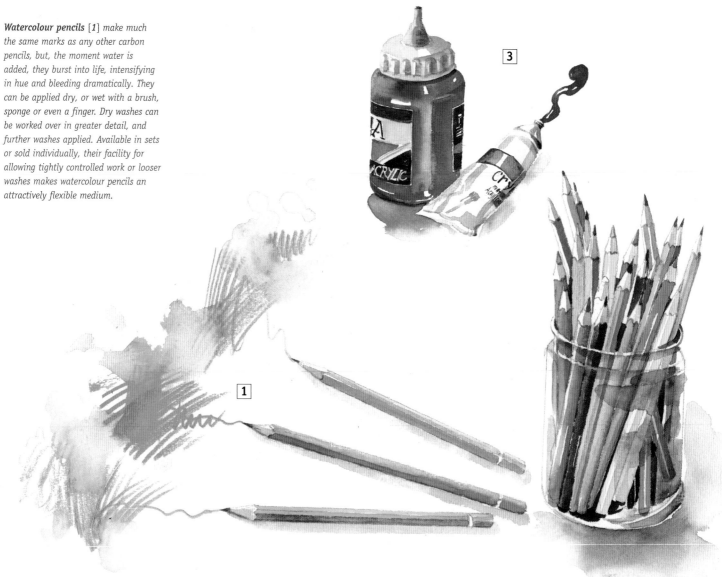

Inks [2] come in waterproof and non-waterproof forms, in a large range of colours as well as black. Use waterproof ink if you do not want your marks to run when another wet medium is flooded on top. With a nib-pen or brush, it is possible to render lines of the highest quality, and the gummy, waterproof varnish the ink contains – known as 'shellac' – gives a hard, glossy finish. (Brushes and nibs must be thoroughly cleaned immediately after use because shellac clogs them up.) Non-waterproof inks contain no shellac and are principally used for laying washes over waterproof inks. With greater absorption into the paper fibres, they dry with a matt finish.

Acrylics [3] were invented in the 1950s. Originally intended for external mural painters, they have revolutionized the world of practical art. The pigment they contain is based on acrylate resin, a plastic emulsion which allows particles to fuse together as the paint dries, leaving a permanently flexible film of waterproof colour. Having the consistency of soft butter, acrylic paint can be applied thick and undiluted, when it forms the perfect 'resist' (water-repelling medium), or it can be thinned as glazes of translucent colour, and used in combination with other media. Brands do vary, but acrylics are available in a huge range of colours and can be bought in tubes, pots and as liquid in bottles. Tube acrylics are the thickest and are available in sizes ranging from 22ml to 200ml (³/₄fl oz to 7fl oz). The best for use with watercolour are pot and bottled acrylics because they are thinner and can be easily mixed. Pots range in capacity from 60ml to 950ml (2fl oz to 2pt).

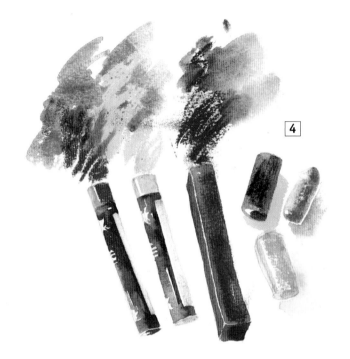

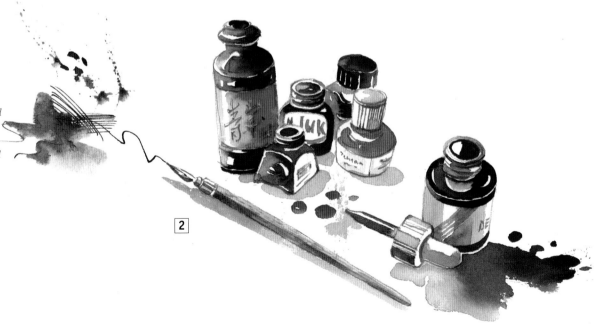

Pastel sticks [4] are made with powdered pigment and bound together by weak gum or resin. There are three main types: hard, soft and oil. All work well with watercolour. They can be bought as single sticks or full sets and in a complete range of colours. Soft pastels (centre) are an excellent means of adding texture and surface interest to a picture. Broken colour techniques (see pages 44–45) can be exploited, especially on rough paper. Being by nature less crumbly, hard pastels (on the right) are more appropriate for linear drawing and flatter areas of colour. Laid under a watercolour wash, oil pastels (on the left) will repel the water, resulting in a slightly mottled or bubbly effect.

Additives and tools

A set of paints and a handful of brushes is all you need to get you going as a watercolourist, but you will naturally wish to increase your potential as you progress through the techniques and projects in this book. Experimentation with various additives and unconventional tools can inspire you to take new journeys into the world of watercolour painting and to explore the unknown outcomes that can be achieved.

Masking fluid is a quick-drying, latex-rubber solution that is handy for masking selected areas of a painting when applying colour in broad washes. It comes in colourless and tinted forms. The tinted version is easier to use because you can see where you have placed it. As it can stain the paper or even remove the surface, a test should be carried out in advance. Keep separate brushes just for applying masking fluid, and wash them out immediately after use in warm, soapy water.

Additives

Plain water is the most basic additive that you can use with watercolour paints to dilute them. There are, however, other additives that alter the way the pigment behaves and allow you to achieve different effects.

Gum arabic [1] is a pale-coloured medium which, when added to watercolour, increases the lustre and transparency of washes. When heavily watered down it also increases the flow. Guard against using too much, however, as it can make the paint slip around on the paper, although interesting effects can result.

Glycerine is excellent for working in dry heat. Just a few drops can counter accelerated drying times due to wind and strong sunshine.

Alcohol [2] in contrast to glycerine, speeds up drying time. It is a useful additive in damp, outdoor conditions, or to shorten the time needed for glazes. Nineteenth-century artists are known to have added their favourite tipple to their pigments, thereby fulfilling both artistic and personal needs!

Ox gall [3] is a pale yellow liquid derived from animal gall bladders, which is added in drop form to the water pot to improve the flow and adhesion of watercolour paints on less absorbent surfaces. It will also prolong the length of time your washes remain wet, which is ideal when painting in hot climates.

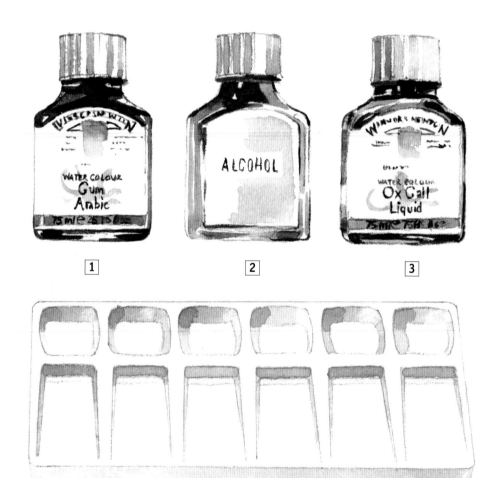

1
2
3
4

Tools

As well as your starter kit of paints and brushes, there are several other tools and pieces of equipment which will answer your practical needs as well as offering you greater creative scope in working with watercolour. (See also pages 50–53 and 100–103.)

Palettes [4] *are usually made of white porcelain, enamelled metal or plastic, and are a necessity when mixing paint. The enamel or plastic lid on a sketching box is normally moulded into a set of small trays for mixing – perfect for on-site work. Slanted-well palettes are tilted to allow pigment to gather at one end. They usually have extra smaller wells included for paint to be squeezed into. Tinting saucers are small and circular and usually divided into four equal trays. Palette trays are bigger and deeper and used for mixing large quantities. A perfectly adequate and much cheaper alternative to purpose-made palettes are old plates.*

Sponges [5] *have multiple functions in watercolour painting. Use them to lift out or blot colour, wet the paper surface, lay washes, and create textures. The best sponges for painting with are natural, with their silky surfaces available in grades of smooth to rough. They are extremely porous. Man-made sponges are best kept just for cleaning up, as they are too unresponsive on paper.*

Scraping tools *for removing paint from the paper surface include razor blades, scalpels, paintbrush handles, cotton buds, and sandpaper. Always test your scraper first on a spare piece of paper to ensure that it will not damage your work.*

A misting sprayer *consists of a water-filled bottle with spray attachment (the trigger-type used in the garden). A very useful piece of extra kit, it dampens dry paper and produces glistening, speckled wet-in-wet effects.*

A hairdryer *is not essential, but is a handy addition to the watercolourist's kit because it can be used to speed up drying times.*

Easels and sketching stools [6] *make painting a more comfortable experience, particulary when on location. Watercolour easels are usually wood or aluminium and tend to work on the three-legged tripod principle. When buying an easel, make sure that it is firm and gives good support, with little movement when you lean against it: you cannot work on a wobbly stand. The best type of stool is a folding fisherman's stool, or a specially designed folding artist's one. The latter is particularly good because it has an integral bag for storing your kit, beneath the seat. Whichever type you choose, make sure that it is lightweight and portable.*

5

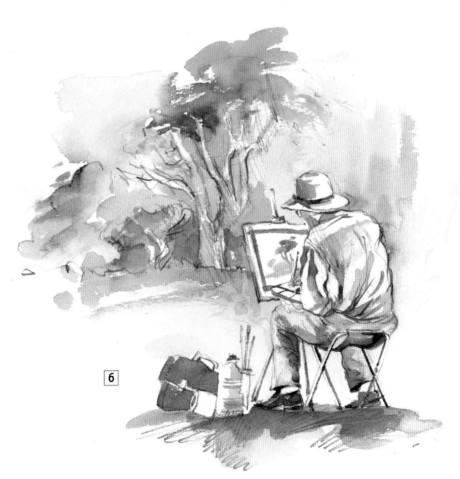

6

Papers and other supports

The surface an artist makes marks upon is known as the support. The chief support for watercolour is paper, although experimentation may lead to work being undertaken on fabric, board, or even primed wood. The benefit of paper is that it is relatively cheap, widely available and portable. A numerous range of white and tinted papers stock the shelves of art shops, and this can leave you with a bewildering choice.

Price varies hugely depending on the content, quality and manufacture of the particular brands of paper. The quality you select will significantly affect the end result, so it is worth knowing what you are working on and why. There are no right or wrong watercolour papers to use; with a choice of rough to very smooth it comes down to preference.

Two methods of production remain in use today: handmade and machine-moulding. Plant fibres – usually cotton – are pulped, and a gelatine size is added to control absorbency. From here, the pulp is pressed onto a woollen blanket, either by hand or through machine rollers, which gives the paper its grain from rough to smooth. It is then dipped in size once more, pressed and finally dried. According to the method of manufacture, watercolour paper is placed in one of three categories: hot-pressed (HP), cold-pressed (CP) also known as NOT – literally 'not' hot-pressed – and rough.

The paper you buy will always be measured in thickness by weight per ream (480 sheets). The higher the number, the heavier the paper, so a 90lb (180gsm) paper is moderately light and a 300lb (600gsm) paper, heavy. Heavy papers are more durable and can be worked over with washes and other techniques without damaging the surface. Unless applying a high-saturation wash, these papers do not need to be stretched.

Traditionally, paper comes in sheets of royal (19 x 24in/483 x 610mm), imperial (30½ x 22⅛in/775 x 572mm), elephant (29½ x 40in), and double elephant (40 x 26⅛in/1016 x 679mm). Some manufacturers also now make paper in metric 'A' sizes. Most papers are available in individual sheets, pads and some in pre-stretched blocks that require you to simply lever a sheet from a gummed block upon completion. These save the effort of stretching, but you will pay for the luxury.

TIP

Tinted papers are prone to fading in the light. A sure alternative can be achieved by applying a tint as a thin wash, by way of a sponge or large wash brush.

TIP

Begin by buying individual sheets of paper. When you are happy with a brand then you should consider buying in pad form or in bulk, which will lessen your costs.

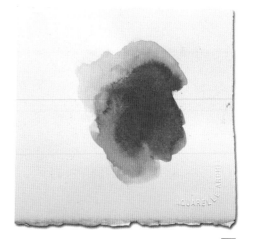

1

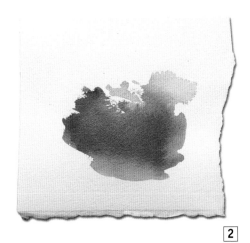

[1]

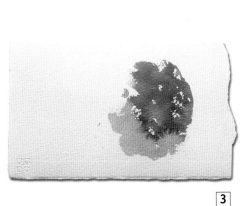

[2]

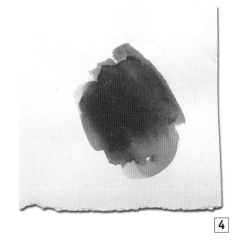

[3]

[4]

Hot-pressed paper [1] is very smooth and suitable for line and wash. It tends to be too slippery for watercolour on its own, and is best for mixed-media work.

Cold-pressed paper [2] is a good all-rounder. It has a semi-rough surface which will take large, even washes and produce rougher marks made when a dry brush is dragged over it. It is the most tolerant of corrections.

Rough paper [3] has a definite 'tooth' to it and produces a speckled look as its surface resists the drag of the brush. Pigment fills the hollows in the paper, but leaves the higher parts bare. It does not suit detailed work.

Cartridge paper [4] is the cheapest type and is bound into most sketchbooks. Smooth-textured and durable, it must be stretched onto a board to avoid cockling, although in a book cockled pages convey an impression of immediacy.

Handmade papers [5] are produced from the highest-quality linen and are the most expensive. Being sized on one side only, each sheet must be held up to the light to reveal the watermark the right way round on the painting side. It may take a good deal of experience to get the best out of some handmade papers.

Oriental and organic papers [6,7] are made from plant sources and are very absorbent. Many oriental sheets contain small amounts of size, or none at all, and are like tissue and very absorbent; they are known as 'waterleaf'. Experimentation in delicate work on these cheaply priced papers can be attractive and rewarding.

Other supports include un-sized fabric, which will soak up pigment and leave a bled stain when dry. Gesso primer, or water-based white emulsion, applied with a house-painting brush to a heavy watercolour paper, board, or canvas-covered board, will make a coarse grain which watercolour will slip over, before drying with interesting bubbled textures and hard-edged stains. Experiment with other materials as supports to discover their potential.

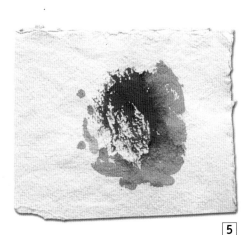

[5]

[6]

[7]

Colour palette

Your working selection, or 'palette', of colours is personal to you. A group of established artists could advise you on the best palette and each would differ over the choice of certain colours. Some colours are universal: open any number of paintboxes and you will find particular traditional colours duplicated. Experience has taught us to respect these grand elders, for they have the same translucent power that they had centuries ago, and so come with a full guarantee. To these may be added any of the brilliant, synthetic hues now on the market, the product of new technologies. A purist may frown, but again the choice is subjective and ultimately yours.

I have recommended a trustworthy list of colours to start you off. Nine colours is ample to begin with and should provide you with the potential to create a full range of useful hues. Having too many colours can be overwhelming, not to mention costly. The evolution of my own palette has been a natural one, and firmly based on known purity of colour, pigment strength, fastness to light and the ability to work well in combination – but it is by no means the definitive collection.

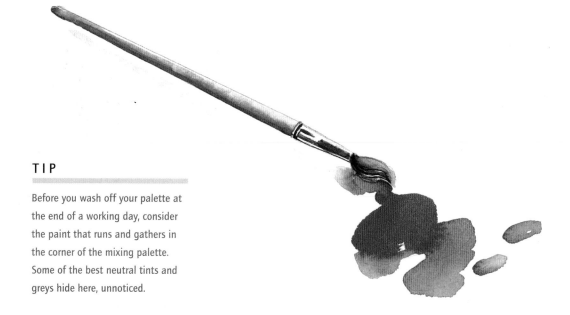

TIP

Before you wash off your palette at the end of a working day, consider the paint that runs and gathers in the corner of the mixing palette. Some of the best neutral tints and greys hide here, unnoticed.

Cadmium red covers well with strong opacity, and softens to smooth pale tints. It is very light-fast, and a little goes a long way.

Yellow ochre is much clearer and thinner than other yellows. Its own special mixing qualities make it a good warmer of greys and other tint neutrals.

Emerald green is a unique, cool colour. With its naturally opaque base, it lends itself to broader washes and finer detail. Its grainy consistency makes it a good mixer with burnt sienna.

French ultramarine is a very pure, granular colour with a violet warmth, which offers good durability. It produces strong, fluid washes.

Purple madder is clear and delicate when used on its own, but also provides the perfect base for mixing richer purple hues. It is very durable and has excellent staining power.

Cadmium yellow is a strong, orange-based yellow and a good mixer, with superb tinting potential and good permanence.

Prussian blue is not very light-fast, but is a vivid mixer, especially for use wet-in-wet. It goes well with all colours.

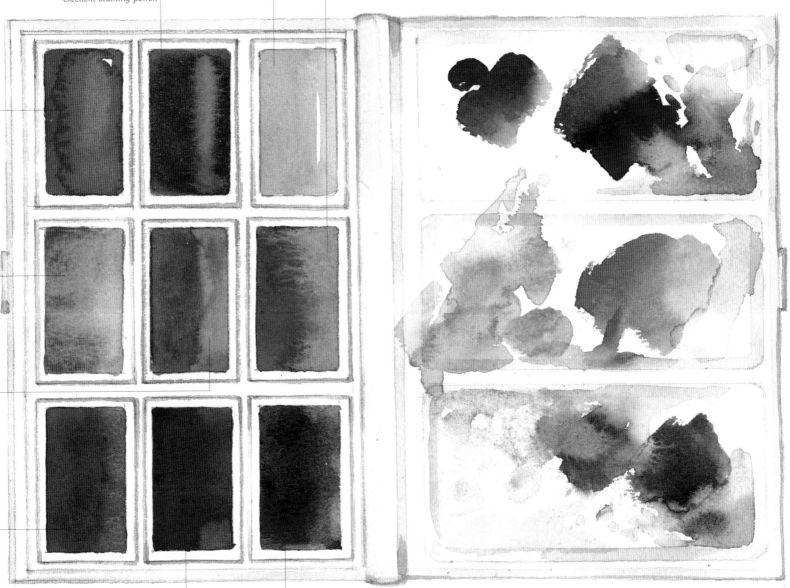

Burnt sienna is an earth pigment with high purity and transparency. Its medium granularity makes it a good mixer. When added to cadmium yellow, it can produce a stain to match yellow ochre.

Burnt umber is a brown that settles on the paper with heavy, grainy deposits. Cooler and deeper than burnt sienna, it tends to make other colours muddy. It is very light-fast.

Learning about colour

We are attuned to recognizing and responding to colour combinations. In nature as well as in art, certain combinations are harmonious and others discordant. The way we respond to colour is intuitive, however, and evokes a totally subjective, emotional reaction. The problem comes when we are forced to rely on this subjectivity to select and combine colours for the process of painting. Colour theory, as originally introduced by Sir Isaac Newton in the seventeenth century, provides us with the means to measure relationships among hues, and to use and combine them to best effect.

The colour wheel [1] is made up of 12 colours and begins with red, proceeds through orange, yellow, green, blue and ends with violet.

Colour language

There are various specialist terms, used to describe the characteristics of colours, that are useful to know. *Hue* is the common name for a colour, such as cadmium red or purple madder, and is normally the name of the pigment before manufacture. *Saturation* or *chroma* refers to the intensity and purity of a colour. Cadmium red, cadmium yellow and French ultramarine blue are highly saturated and so are the closest we can get in pigment to the pure red, yellow and blue primaries. Unsaturated paint, on the other hand, is either transparent, or mixed with a lighter colour to produce a *tint*, or mixed with a darker hue to produce a *shade*.

Tonal value refers to the lightness or darkness of a colour, which varies according to the amount of light falling on it. *Colour temperature* describes the warmth or coolness of a colour. Those associated with sunlight – red, yellow or orange – are warm, while those associated with shadows – blue, violet or green – are cool. A warm hue placed beside a hotter one will, however, appear to be cool and vice-versa. When used in compositions, warm colours optically jump forward where cool colours recede into the background.

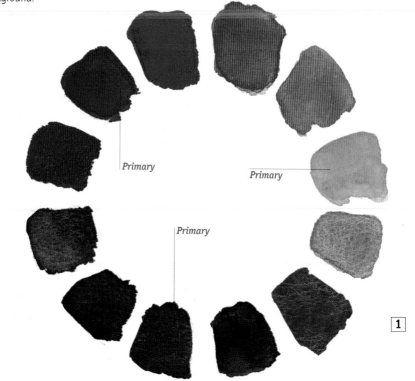

Primary

Primary

Primary

1

The primary colours [2] are red, yellow and blue. They are so-called because, in their purest form, they cannot be mixed from any other colours. In theory, it should be possible to create any colour by mixing these three primaries.

The secondary colours [3] are produced by mixing two primaries together in equal quantities – so red added to blue makes violet, yellow and red together make orange, and blue combined with yellow makes green.

The tertiary colours [4] are much harder to define. They are created when two primaries and a secondary are mixed together. The result is reddish-oranges, yellowish-greens, bluish-greens – tints that hint at warmth and coolness, and appear between the primaries and secondaries on the colour wheel.

Complementary colours [5] are those that are positioned directly opposite each other on the colour wheel, and offer the strongest contrasts. Red and green, blue and orange, and yellow and violet are good examples. The most harmonious colours are those that lie next to one another around the circle: for example, red and orange, and purple and blue. Complementary colours are always paired together as one primary with the combined colour of the remaining two primaries, which becomes, of course, a secondary colour. So for example, the primary red is the complement of the secondary green, which is created by mixing the remaining two primaries, blue and yellow.

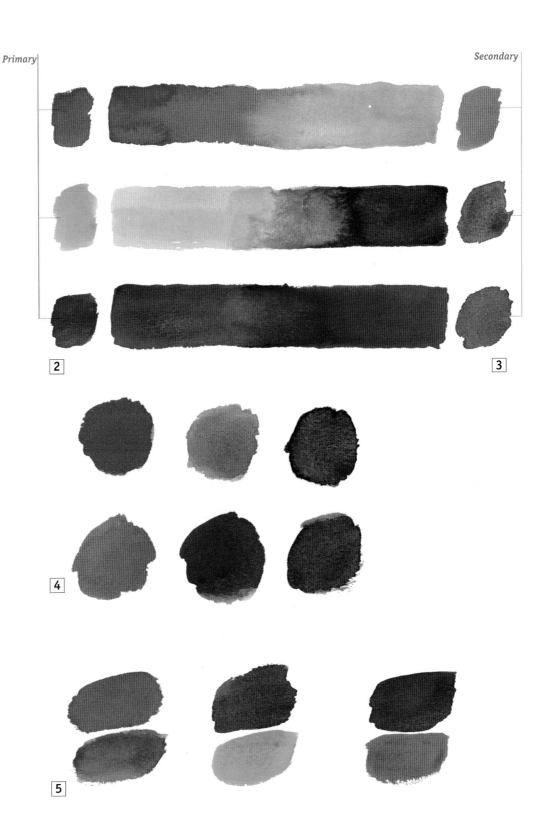

2

3

4

5

Learning about tone

Black and white represent the two extremes of lightness and darkness, and in between are infinite gradations of grey. The term used to describe the perceived lightness or darkness of a colour is 'tonal value'. An understanding of these values, and how to make use of them, remains key to conveying depth and volume in all forms of painting.

Tonal values are relative and vary according to the effect that adjacent colours have on each other. For example, the same mid-grey may appear light placed next to a deep red, but sombre against a pale blue. In addition, it is a misconception that light colours all have light tonal values. A vibrant yellow painted beside a mid-green may appear to contrast, and certainly they have different colour saturation, but when converted into greys using a computer scanner or black and white photographic film, the tones are revealed as very similar.

The contrast between two tonal values may be used to give 'weighting' to elements in a composition. The greater the contrast – for example, the white of an object under a strong light source meeting the black of its spreading shadow – the greater the 'weight' of that object.

Coloured neutrals [1] *are formed by mixing any three unsaturated colours, and these mixes will harmonize with purer washes of the colours from which they have been derived. This use of what is known as 'low-key colour' can help you to realize the full breadth of tonal range.*

Luminous greys [2] *are those created by blending two complementary colours. They have a more pronounced base colour than neutrals and give low-key tonal studies a glowing warmth. The apparent brilliance of a pure or saturated colour is enhanced by its proximity to grey, especially if they are complementary. So, for example, a luminous grey strongly based in cool green will enhance the fiery warmth of a strong red wash, red being complementary to green.*

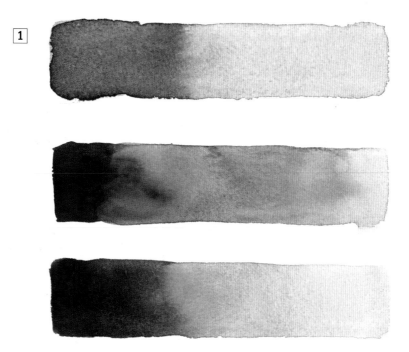

Two-colour neutrals

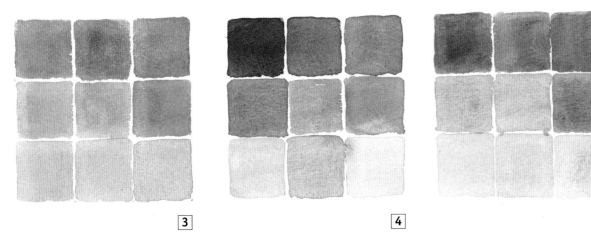

3 4 5

These tonal grids, made up from two complementaries, demonstrate the surprising range of tones available for the subtler passages of your paintings.
A red and green mix [3] gives a range of soft tones to work with. Violet and yellow [4] mix to create both warm and cool grey tones. Blue mixed with orange [5] results in a more earthy range of tones.

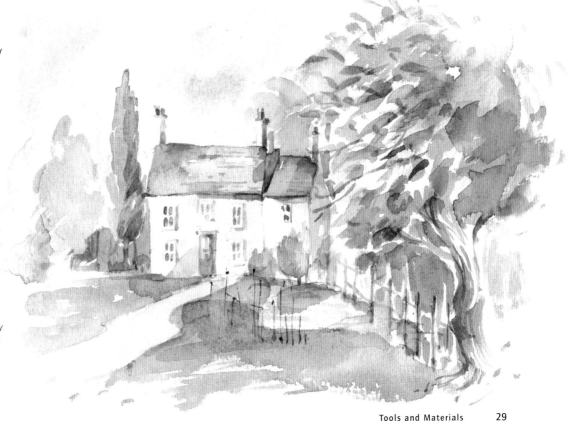

This simple watercolour sketch of a house amongst trees uses various mixes of neutral grey to evoke the warm, ambient afternoon light and to give a sense of three-dimensional depth.

Techniques

Brushmarks

Learning to handle your brush is fundamental to your skill as a watercolourist. Brushwork gives expression to your art and can be manipulated in various ways to produce endless marks of differing quality. Used vigorously, the effect is one of energy and spontaneity, and when subtly controlled the result can be light washes of extreme delicacy.

Having familiarized yourself with various types and sizes of brush, spend time just allowing these tools to take the lead. Load them with colour and take your 'line for a walk', an idea first verbalized by Paul Klee, the great twentieth-century watercolour master. By exploring the strokes you can make you will learn your basic vocabulary. Take a few seconds to consider your grip. A brush is a finely balanced tool with a gently tapering handle, so the centre of balance is much nearer to the ferrule (the metal sleeve that keeps the hairs in place). Find this centre by evenly balancing the brush on your finger.

For a loose grip, hold the brush halfway along the handle between forefinger and thumb, in much the same way as you would clutch a small card. Keep your wrist flexible as you wield the brush, to make marks that are light and free.

To attain finer, more controlled marks, a tight grip is necessary. Hold the ferrule section of the brush as you would a pen or pencil. Vary your grip position to adjust the control.

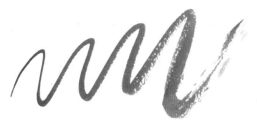

Round brushmarks are best practised with a size 8 brush. Load the brush and make a continuous stroke, increasing the pressure to full brush width.

Make a straight line with only the tip.

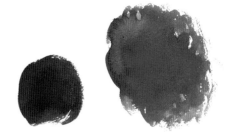

Create wider, broken-ended passages of colour by rolling the fully loaded brush through 360° turns.

Paint dots of increasing size, using a circular motion and applying increasing pressure, to test the springiness of the brush.

Vary the direction of the marks using only the tip.

Use a very wet brush to gather thicker pan paint and drop onto the paper.

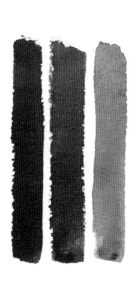

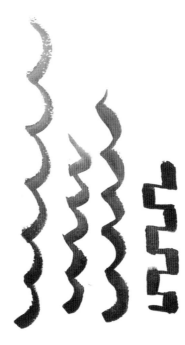

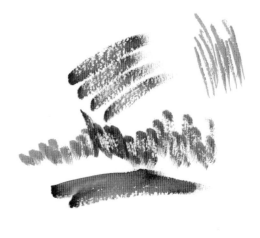

Flat brushmarks *may be explored with a 2-inch brush or its numbered equivalent. The natural stroke of a flat brush is like laying a mini wash – smooth and consistent.*

Wavy patterns *appear more stylized with a flat brush. Alter the angle of application to change the shape and width of the strokes.*

Dry and broken brush effects *are achieved with the side of the brush.*

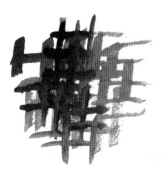

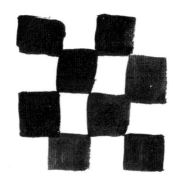

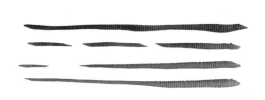

The direction and pressure *of the marks can be varied as you work.*

Chequerboard patterns *exploit brush versatility.*

Thinner, strong-edged lines *are made using the tip of the brush.*

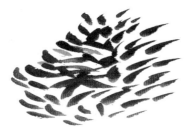

Square dots *are made possible by drawing with the corner of the brush.*

Feathery, upward strokes, *laid dry, translate into foliage.*

To create open marks *wipe the side of the brush clean and drag the dry brush across the paper.*

Washes

Imagine a small painting hanging in the hallway of a house that is the envy of all who visit. Its secret lies in its method. It is a watercolour landscape, exquisitely simple, in which each blob and fleck of paint takes on recognizable form. The rich and luminous colouring of the sky filling two-thirds of the painted surface has been confidently laid with perfect flatness, with the technique that forms the very basis of watercolour painting: the wash.

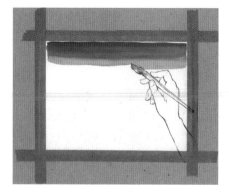

To lay the flat wash, apply colour to the surface, moving the brush back and forth, from top to bottom, to achieve a continuous tone. Using a well-charged wash brush, draw it along the paper in a horizontal band, keeping the board tilted at a slight angle so that excess paint gathers at the bottom of the band. Pick up the excess paint at the end of the line, drop the tip of the brush to line up with the bottom of the band, and draw the brush to the other side of the paper, moving in the opposite direction. Continue picking up the paint with each stroke, and keep it moving smoothly in a continuous motion.

The transparency of watercolour imposes immediate limitations on anyone starting out in the medium. Light paint cannot overlay dark, and pigment is best applied in layers to build up nuances of colour and tone. Washes – dilutions of pigment freely applied – exploit the characteristics of the medium, allowing you to cover large areas rapidly, and to intensify and alter colour and tone with each successive layer of paint. Learning to control the movement of the paint does take practice, of course, but what better way to explore the magic of the medium than to splash around with pools of glistening colour?

A flat wash

The basic flat wash reveals pigment at its most subtle and transparent. When attempting to cover an area with colour, you will discover that water saturation, paper surface and room temperature can all have an effect on the end result. It may be harder to gain total flatness on a smooth paper, where the wash may be prone to streakiness, or on a rough surface where the paint may settle in the troughs.

Stretching paper

Lightweight papers need to be stretched or they will buckle when wet paint is applied. Papers of 72lb (150gsm) to 140lb (300gsm) must be soaked in a bath or tray of water for several minutes before being taped out onto a wooden board with brown, gummed paper tape, known as gum-strip.

Preparation time is at least two hours and you will need to take this into account before intending to start work.

1 Check that the paper will fit the board and cut your gum-strip into measured lengths that are slightly longer than the paper size.

2 Submerge the paper for several minutes to fully soak it.

3 Lift the paper gently out of the water, holding it by the corners, and allow excess water to drain away. Use a damp, not wet, sponge to wet the lengths of gum-strip, one at a time.

4 Carefully lay the soaked paper onto the board (correct side up) and stick each edge to the board with the dampened gum-strip tape.

5 Allow the paper to dry naturally. Intervention may destroy the surface or even cause the paper to crack.

Laying a graded wash

This is done in much the same way as a flat wash, progressing from dark to light by adding a little more water to the loaded colour with each successive stroke.

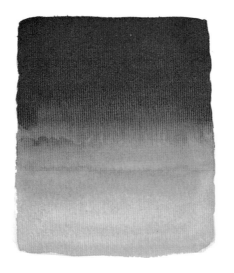 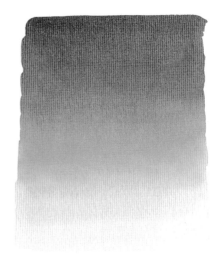

Use a sponge to dampen the surface of the stretched paper.

Lay the board flat and apply your brushstroke quickly across the top of the paper.

Rapidly dilute the pigment with water from a pot and continue to stroke the surface until the colour is no longer visible in the water.

For a stronger tint, add more colour from the top while it is still wet.

To finish, tilt the board at 45° and let the colour run downwards. If paint pools at the base of the paper, lift off with a clean, unloaded brush.

The variegated wash

This wash consists of two or more colours merging on wetted paper to produce soft colour blends. Painting a sunset puts this technique to good use.

TIP

Be careful when dampening the gum-strip tape. Over-saturation can prevent it from adhering to the board and paper.

Select your materials and mix your colour. Take one water pot to clean brushes and one to mix paint. If you are laying a wash over a large area, you will need greater quantities of pigment, so use tubes; for smaller areas, use cakes or pans. Mix plentiful quantities of strong colour in a palette or on a plate, using a bristle brush to break the paint down more effectively. Have your support to hand, ideally a piece of paper of at least 140lb (300gsm) in weight and stretched on a board (see also page 22), to prevent cockling and the formation of unsightly puddles.

To achieve the wash, have the board tilted at an angle and down the lightest colour first, allowing it to flow to halfway down the paper. Then turn the paper upside-down and repeat with the darker colour. The second colour will blend with the first. This can be controlled by the length of time the board is tilted.

Wet-on-dry and Wet-in-wet

These two techniques are an extension of the basic wash technique (see pages 34–35), and are equally important to your skill as a watercolourist. Wet-on-dry is a controlled method which exploits the luminosity of watercolour and can produce wonderful effects that are so characteristic of the medium. Wet-in-wet, on the other hand, means literally 'going with the flow', and involves a more spontaneous approach, controlling the fluid spread of colour just enough to produce the desired effect.

Wet-on-dry

Commonly used in most genres of watercolour painting, wet-on-dry allows passages of colour to be cleanly overlapped without defined edges bleeding into one another. A type of glazing, it is as perfect for pure, saturated pigment as it is for pale, luminous washes, and allows the viewer to fully appreciate the special qualities of this special, translucent medium. I enjoy it best when pigments of different texture overlap – perhaps a smooth cadmium yellow shifting over a grainy blue – where the contrast emphasizes their opposing qualities.

A wash laid wet-on-dry will alter in colour because it allows the underlying hue to show through. Try this with two equally saturated colours. Lay the first wash and allow it to dry totally, then overlay it with the second colour. Note how the new wash rests on top of the first one without displacing it, and how the colour underneath still shows through the top layer, creating a new hue.

Watered-down washes work in exactly the same way. Repeat the same process as above, but this time use more diluted pigment. When absolutely dry, lay another thinned-down colour on top.

Wet-in-wet

When painting wet-in-wet, it is best to be direct, working with the brush at all times. I adore the reactions caused when hues clash and collide on the damp surface of the paper. As you begin to explore the technique, lay any expectation of possible outcomes aside: the resulting image is ultimately beyond your control. Guiding the water by pulling the brush or tilting the paper are the only means of manipulation at your disposal. Excellent for depicting water or scenes with low definition, the process is one you will soon find seductive.

TIP

Avoid using smooth or heavily sized papers with wet-in-wet techniques because the paint will not easily be absorbed. Not paper is ideal, and sheets of over 200lb (410gsm) will resist cockling without being stretched.

First dampen the paper surface with clean water and a wash brush, sponge or misting sprayer. Mix up plenty of wet pigment and, when you are ready to begin, drop your colour onto the paper. It will spread from the centre of the brush immediately and get paler as it disperses.

Further 'loads' dropped into the wet paint will develop its tonal range from light, gauzy tints to full-bodied, saturated passages.

Lifting colour to lighten the image can be done with a brush. First dry off the hairs, then press them down onto the paper and lift gently. The colour is absorbed by the brush-head and the area is significantly lightened so that the paper texture shows through, while still retaining the soft edges.

Intensify the image by adding another colour.

Soft definition can be achieved by using a darker hue, and pushing and pulling it to gather the darker tones to form the desired image. As the paint begins to dry and becomes lighter, darken down to the desired tone by adding more pigment and water.

Increasing definition can be achieved by allowing the water to dry off. The longer you leave it, the stronger the definition.

Hard and soft edges and Building tone

To successfully incorporate wet-on-dry and wet-in-wet techniques into your pictures, you will need to learn a little more about edges – the visual dividing line between one object and the next – and how to treat them to create a sensation of three dimensions and spacial depth. Layering colour to build up tone will also add to this illusion.

Hard and soft edges

Consider how objects at a distance appear soft and blurred – their intricacies appear as mere shapes in a range of hues and tones. Objects close by, on the other hand, are crisp with sharp detail and on a sunny day you will notice strong contrasting shadows and hard outlines around them. By exploiting these qualities you can imply distance in a painting – a phenomenon known as 'aerial perspective' – using what we term 'hard' and 'soft' edges.

TIP

Leaving small gaps between hard edges prevents inadvertent creation of soft edges. This can be especially useful when working outdoors, dividing the main elements of sea from sky or land from sea.

Hard, crisp edges are created by painting wet-on-dry. To test this, select two contrasting hues, for example a blue and a red. Charge your no. 8 round brush with red paint and draw a single band of colour across a sheet of dry NOT paper. Rinse the brush and do the same with the blue just below the passage of red, allowing a gap of no more than 5mm (1⁄4in).

Allow full drying time between the painting of each band then repeat the exercise. This time, however, close the gap and note how two abutting colours still retain their hard edges.

Soft edges may be created by painting wet-in-wet. Again, lay the same two bands of colour with no gap, but this time do not allow either to dry. The merging of colours forms a soft edge that does not completely dissolve into a wet-in-wet blend.

Paint two final bands next to each other on paper dampened with a misting spray, wash brush or sponge to appreciate the different softness. As the two colours collide, a pale, watery puddle will form between them and separate them with a very soft edge.

Building tone

Now that you have experience in the practice of hard and soft edges, use your skill and knowledge to build up tones. The same rules apply. When your brushed stroke is dry, lay another band of wet colour over the top so that it partially overlaps the first. The wash beneath will remain intact and the second layer will create a new, deeper, more saturated colour, as can be seen in the overlapping bands of translucent colour in the example below.

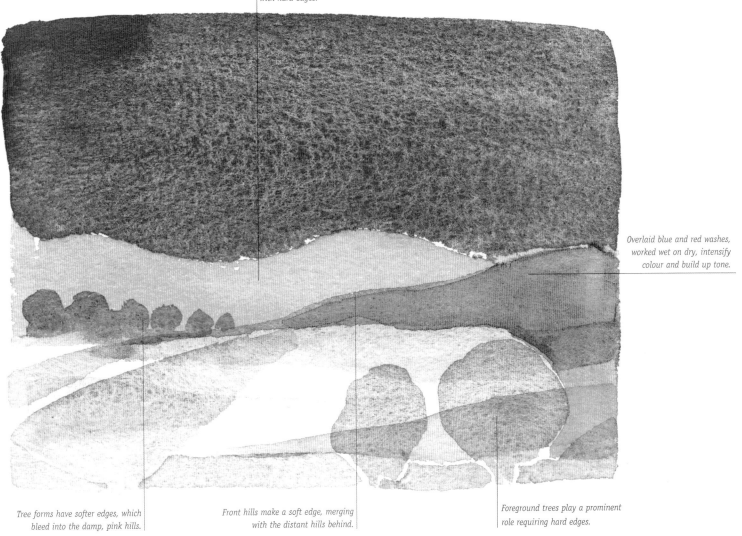

Pink hills butt up to the sky, also with hard edges.

Overlaid blue and red washes, worked wet on dry, intensify colour and build up tone.

Tree forms have softer edges, which bleed into the damp, pink hills.

Front hills make a soft edge, merging with the distant hills behind.

Foreground trees play a prominent role requiring hard edges.

Reserving and Lifting out

White is of vital importance to watercolour. An area with no pigment allows hues to appear in their truest, brightest and freshest form, with full intensity and correct colour value. White is the 'palest' of all tints, striking a contrast against the subtlest stains. Reserving and lifting out both take an area back to white. Reserving involves leaving blank paper to produce whites; lifting out needs deliberate intervention.

Reserving

Watercolours of the greatest brilliance are those in which the light reflected off the paper shines through the translucent washes on top. The maximum reflection always occurs where 'bare' white paper has been left unpainted, in the technique known as 'reserving'.

When you want a pale tonal block to stand out from darker washes, you should use the technique of reserving – working always from light to dark. Sparkling light, glistening upon gentle ripples at sea provides one of the best examples, especially when it is displayed on rough paper. Using the reserving technique requires forethought and planning as well as careful brushwork. It is usual to be left with hard edges around your white paper, but if soft is preferred, make sure that you dampen the paper beforehand or blend soft, coloured edges into the whiteness with a damp brush.

Painting single, bold strokes with a large, round brush creates white fragmenting shapes with a definite hard edge. This technique is especially effective where a new, paler colour is laid into the shapes as a tint.

Dragging a wash brush in a downward direction speckles the reserved area with colour. As the brush moves pigment over the surface, some rests in the troughs of the paper, causing the pitted, broken effect. This technique is ideal for sparkling water reflections and atmospheric skies.

A mixture of the previous two techniques can also be used. Larger areas are reserved first and, before the pigment has time to dry, the brush is dragged with drier pigment up to the edges of the larger shapes. The random result is especially useful for wall textures.

Lifting out

Highlights can also be attained by removing pigment from the paper while it is still wet. You can do this on a dry surface, too, although success will depend very much on the type of paper used. A hard, hot-pressed surface will prove very difficult, and you may be left with a pale stain, rather than a fully lifted-out patch of white. Other soft-sized papers may also prove difficult.

Soft, diffused whites are produced by lifting pigment off the surface, an effect that is especially suitable for conveying high-stacking cumulus clouds. Begin by gently flooding water over the area where you want colour to be lifted, then carefully dab it, using a sponge, kitchen towel or soft, mop brush. Concentrate on the removal process and have your water pot and clean brush at hand to loosen any deep-set pigment that has not yet lifted.

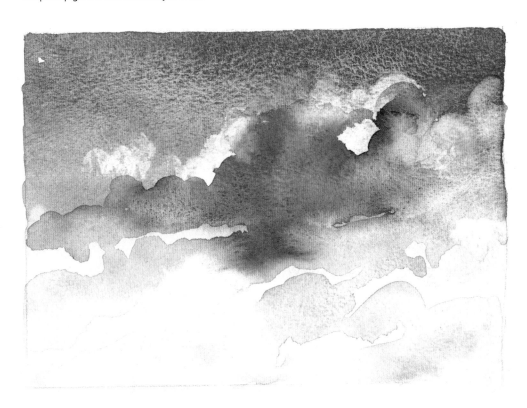

Using flat colour, a fluid wash has been applied to the upper band of the sky and cloud formations, and areas have been reserved as white around a few of the edges. While the paint was still quite wet, the edges of the clouds were softened with a natural sponge.

TIP

Where a residual stain is hard to remove, hot water could be substituted for cold as it can help to dissolve gelatine size. Staining powers differ according to their pigment base. Lift off an assortment of colours from a selection of papers and keep the results for handy future use. Experiment too with a variety of textured lifting tools to alter the appearance of your whites.

Washes and paint handling

Hopefully, you have arrived at this point feeling reasonably satisfied with your first dabblings in media and mark-making. The importance of mastering your vocabulary of techniques cannot be stressed enough, and even the most experienced of artists need to 'train' their hand and eye on a regular basis to stretch their potential as demonstrators of creative visual expression.

Laying washes and controlling this aqueous medium over such large surfaces of paper is not as easy as it often looks, but take heart: the levels of accomplishment present in masterful pictures, both ancient and modern, are the result of fifteen or perhaps even twenty or more years of study and graft. In short, there is no substitute for putting in the time and effort that watercolour deserves in order to reap rich future rewards. These little 'recap breathers' are important in helping you to maintain levels of personal esteem, and to evaluate your work through constructive criticism. It is comforting to know, through the issues raised on this and other spreads, that you are not alone. Act upon the advice given where you identify with a particular problem, and then move on!

Uneven washes

You may have found that your washes have not laid totally flat, and that pronounced banding has occurred, resulting in uneven streakiness across what should have been a smooth, coloured sweep [1]. When laying washes, it is common to get caught out by not having mixed enough paint and then, mid-process, finding yourself desperately trying to mix up more of the exact hue – a virtual impossibility! Under these circumstances, banding is unavoidable. There is little you can do to correct this, so put it down to experience, and learn from the error by mixing up plenty next time.

Dilution

Another cause of streaky washes is the addition of too much or too little water as you paint. The balance needs to be just right and the ability to approximate correct quantities of water to pigment are quickly learned through practice, in much the same way as a cook learns to gauge ingredient measures. The examples show characteristic flaws in wash painting, with the brush having been too wet [2] and too dry [3].

1

2

3

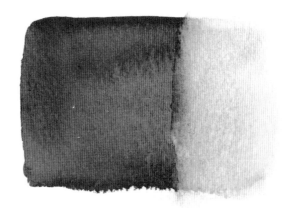

4

5

Working a dry wash

If you have committed yourself to a wash that is really too dry, and which therefore cannot be rectified with extra additional water, then reassign it to work as a dry wash. Striping will occur as you draw your brush across the surface and you may even be able to lay a second translucent layer on top of the lower one [**4**]. Bands look definite and can successfully denote fields in the landscape or deeper waters in a seascape. Although your dry wash may have occurred by default rather than design, use it deliberately in conjunction with wetter, fresher techniques to keep the picture 'alive'.

Brush size

Lack of confidence can cause beginners to over rely on small brushes, based on the myth that you are more in control with more delicate mark-makers. This problem may also partly have its root causes in childhood experience. From an early age, infants are exposed to small sets of cake watercolours supplied with a stiff, hairless brush, blissfully unaware of the possibilities afforded by their larger, softer counterparts. Small brushes are useless for laying the necessary sweeps of colour as their load capacity is too minimal and their coverage so slight.

Lifting out

It ought to be mentioned that lifting out also has its uses as a remedy for reducing the strength of heavy brushwork, and for removing unintentional mistakes [**5**,**6**]. Plenty of water must be flooded onto the selected area and carefully absorbed by the full head of a soft brush (no. 8 or above, or a more specialized 'mop'). The method requires much care, and success in part depends on the type of paper you have used. Smooth, hot-pressed papers allow greater absorbency, as do certain rough and handmade papers with little or no sizing in their manufacture. When dabbing the colour, bear in mind the effect you are trying to achieve. Heavy pressing will potently lift pigment, but what remains is a hard-edged, white space, and this can ruin the softness of a sky, or the modelling of a delicately highlighted form.

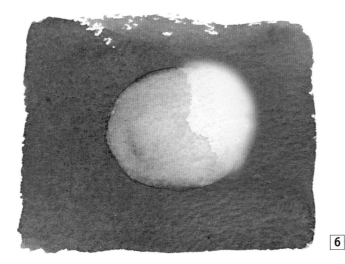

6

Broken colour and Body colour

Flat washes of colour laid on top of each other can lose their radiance, and your paintings can be trapped in a formulaic pattern. Broken colour and body colour are very useful techniques to avoid this problem. In the broken colour method, flecks of colour mix optically on the paper, their strong contrasts creating vibrancy. Body colour involves laying larger, flatter washes of opaque colour (gouache) that work as a contrast to softer washes or paper tones.

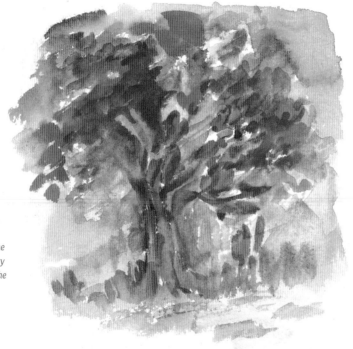

This simple tree study uses broken colour to exaggerate the fullness of its spreading canopy in a warm, summer setting. The cool blue plays off against the vibrant orange and crimson to give brilliance and depth.

Broken colour

The effervescent sensations of light created by the Impressionist painters in Europe at the turn of the twentieth century epitomize the technique we call broken colour. Claude Monet's sequential light studies of cathedral façades, haystacks and water lilies all epitomize the technique. The effect is achieved by using pure colour without any mixing or blending. Flecks of the chosen hue are dragged stiffly across the grain of the paper and any previous layers show through where the paint does not settle. When viewed from a distance, these colours are often blended together by the eye, creating the illusion of a third colour. This is known as 'optical mixing' and is all part of the wonderful game played by the French artists. The great thing about broken colour is its ability to retain vibrancy, regardless of the method by which it is laid. Think about how you might like to use the technique in your own picture making, and experiment with applying the flecks of paint in varying dilutions, from wet to dry.

The optical mixture *of green and red flecks viewed at a distance will create a new brown hue. The white spaces in-between the flecks will attract full light reflection, making the area glisten.*

By dragging a large brush *once over a textured paper significant areas are reserved. When dry, these white areas are tinted; the effect is of broken colour, as though a bottom layer of blue is showing through the red.*

Body colour

Paint which has opacity rather than transparency as its chief characteristic is called 'body colour'. Gouache is the popular form manufactured in much the same way as watercolour, but with added white. The white makes it opaque, and it can be broken down through dilution into washes of colour. Just like watercolour, all hues are available in tube form and are usually marked as 'designer gouache'.

Body colour can also be used for highlighting, a technique which is not new. Dürer was a purveyor of fine line strokes of white on tinted papers and Turner often integrated sparkling tips of white into his travel sketches to accentuate the effects of light falling on dramatic scenes.

Toned paper provides an interesting support for body colour work, as in the examples here. Forms are created by painting the lightest tones first, using undiluted gouache with touches of added colour. Darker tones are made with less pigment. Diluting the consistency allows more of the toned paper to show through, and the dark shapes emerge.

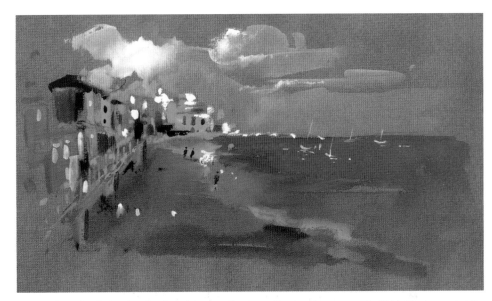

This sketch employs body colour in a loose but conventional way. The strongly opaque, white highlights glow against the deeper tones of sea, buildings and grey-toned paper, adding an extra dimension to the composition.

Washes *of body colour work well because of their high levels of pigmentation. However, because of the paint's dense opacity, it is difficult to attain the brilliance revealed in pure watercolour.*

Impasto *means applying the paint thickly from the tube, like oil paint. In this state, it will cover any water-based colour, reflecting all transmitted light rather than absorbing it, as is the nature of pure watercolour.*

TIP

Body colour is most potent in a picture when it is used with some reservation. Over-use of its special qualities can deaden the brilliance and life present in a watercolour, leaving the overall impression as a very flat one.

Dropped-in colour, Backruns and Spraying

The most unpredictable techniques are often the most challenging and exciting. Watching what happens as one colour is dropped into another, while both are still wet, is as interesting as the final result. Backruns are a variation on dropped-in colour, but the flower-headed shapes occur as a result of the second applied colour being wetter than the first. Spraying is the most different because it can be used to soften edges and create spattered patterns after the paint has dried. All three dislodge pigment particles, and refresh the paint's colour combinations and tonal relationships.

Dropped-in colour

At any stage of the picture-making process, colour can be dropped into a wash and left to run into wet colour. It is similar in approach to wet-in-wet, but little or no attempt is made to control the flow. The accidental nature of the technique makes it ideal for creating more interesting base washes and backgrounds, onto which detail can be laid.

Apply dropped-in colour with confidence and weigh up any accidental results against further layers that might be applied. Keep an open mind and use strong or contrasting colour combinations and your sheets should provide an exciting background that ease the task of painting an evocative scene, by the simplest method.

Dropping a pure, dense green into red considerably affects the green by deepening it into silhouette shapes. This technique is worth noting where you want indistinct shadows to appear in your subjects.

Dropping orange into red achieves quite a different effect. Being of similar hue and tone, they harmonize, although the pool of orange is still strong enough to push the red back into the top third of the picture.

Backruns

When a fresh wash is flooded into one that is still a little damp on the paper, particles of pigment are dislodged from the lower wash and break the uniform flatness to form cauliflower-like shapes with crinkled edges. Spreading naturally out into pale circles, these backruns, or blooms as they are sometimes known, form a strong, stained watermark. Blooms often occur accidentally and anyone starting out may find this distressing – but they produce an effect quite unique to watercolour painting, and one which many experienced watercolourists devote much time and energy perfecting. Soft-edged blooms are made by dropping colour onto very wet areas; less wet surfaces will result in sharper definition. Backruns can be easily adapted to convey rough boulders, trees, hills, heavy clouds and moving water.

Backrun blooms can suggest figurative forms. As the paint dispersed, this rich mix of alizarin crimson, violet and cerulean blue hinted at flower shapes. Further passages of wet paint were dropped into the drying washes to form new backruns, until a vase of flowers emerged.

The extent to which a backrun will form the typical, circular 'cauliflower' bloom is due in part to the watercolour stains being absolutely correct in consistency and fluidity.

Spraying

Mottled patterns appear when a damp wash is disturbed with a fine misting of cold water from a domestic spray bottle. The closer the spray to the surface, the more dramatic the movement of colour across the paper.

A mixed solution of colour could also be sprayed from the bottle to produce a very fine broken colour effect. This will be most successfully achieved when the paper has dried.

A right-angled, hinged metal tube known as a spray diffuser is also very handy for the dispersion of fine particles. It is best used with bottled inks or watercolours, as the well of the bottle is deep enough to stand the diffuser in it.

Wet washes of red and yellow were laid side by side and a water-filled garden sprayer misted the painted area. Soft, slightly speckled blooms pooled across the surface, with greater subtlety than in the backrun technique.

A misting spray was used to soften the foliage and trunk, painted wet-on-dry, causing the fronds to merge into the sky and the trunk into the ground. The spreading paint increased the impact of the canopy.

Dry-brush

The dry-brush technique involves applying paint with a lighter touch than usual, and bridges the gap between painting and drawing – many art dealers still refer to watercolours as 'drawings', and this in part is due to their delicate use as a dry-tinting medium when first popularized. Dry-brush is best suited to a specific range of effects, in particular, for conveying the textural quality of foliage and trees, grass, hair, fur and feathers. The examples here show some of the wide range of effects you can achieve.

TIP

You will need to practise dry-brush to become proficient. If you use too little paint you will not cover the paper, but if you apply too much you will flood the area with a blotchy wash.

Dry-brush is also good for making gestural, textured marks and for creating broken colour on NOT and rough papers where the pigment flows into the troughs and over the crests of the paper surface. Do not over-use it, however, as it can make a picture look static and dull. Instead, combine it with complementary techniques.

Dry-brush is a quick way of producing fine, linear marks that would otherwise take hours with a size 0 brush. Having blotted the brush hairs dry on kitchen towel, proceed by 'scraping pigment' from the pan or palette, then deftly stroke this onto the paper so that the fibres separate and deposit spreading, feathery marks.

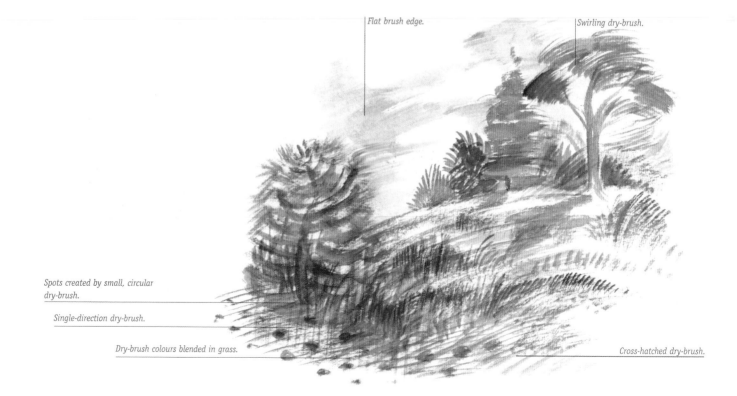

Flat brush edge.

Swirling dry-brush.

Spots created by small, circular dry-brush.

Single-direction dry-brush.

Dry-brush colours blended in grass.

Cross-hatched dry-brush.

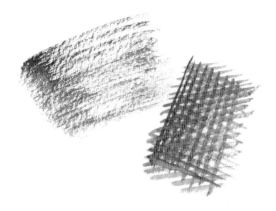

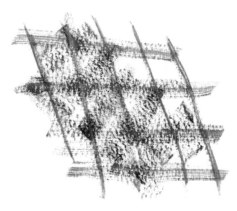

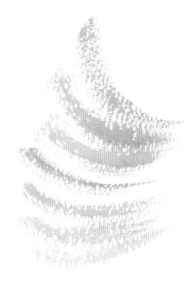

To cross-hatch with dry-brush, *first use single direction dry-brush. Load a small wash brush with dry paint and drag it across a NOT or rough surface. As colour breaks, strong, linear marks form. Then, with a finer, round brush and dry paint, cross-hatch as with a pen.*

By using the tip and edge of a flat brush *a textured lower layer is made. Hold the brush vertically and press evenly with the hair to produce blocks of pigment that mirror the brush shape. Dragging the same brush along just one edge produces the thinner, overlaid lines.*

Circular movements *add strong rhythms to compositions – especially good in gathering skies or across undulating hills. Building up layers of these movements can be very effective.*

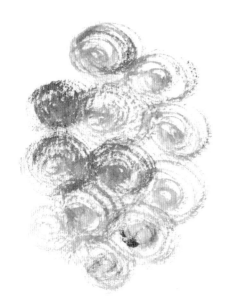

Using swirling motions, *tighter concentric circles build up patterned tones for use when describing more specific textures or forms. Like multiple 'bubbles', these swirls are most effective when duplicated en masse.*

By blending two dry-brush colours, *harmonies and discords can be set up as you drag one hue over another. The result is like broken colour, but with more subtleties, which can add a very strong atmosphere.*

Practise your tonal ranges using a dry brush, *remembering that with the correct pressure applied you can achieve scales of 10 (darkest) to 0 (lightest). Tones can be worked up to achieve great density.*

Creating textures

Texture can be introduced for a number of reasons. Perhaps it has a literal purpose, to describe foliage, rock formations or building materials, for example; or maybe its function is purely decorative, to enrich or enliven a particular surface. Both traditional and non-traditional techniques may be used. Some of the most successful compositions are those that combine well-considered content with both approaches, playing one off against the other. Be prepared at all times to include a 'happy accident': an unplanned effect that enhances a picture is always to be welcomed.

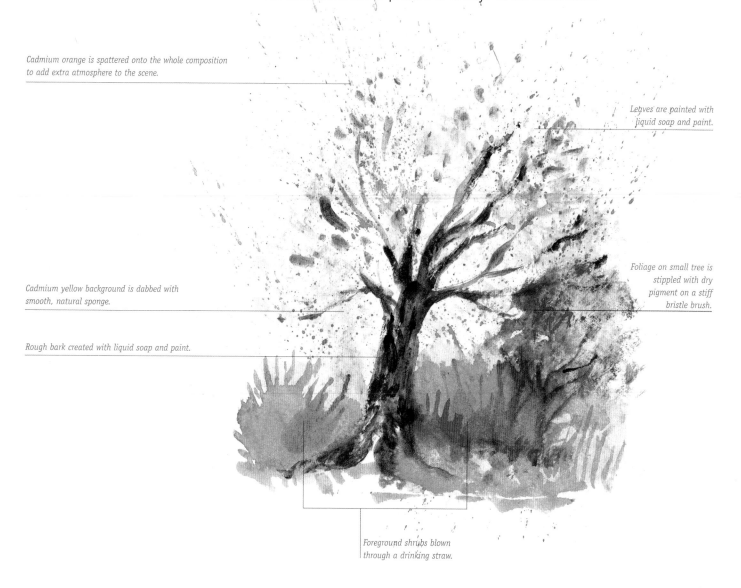

Cadmium orange is spattered onto the whole composition to add extra atmosphere to the scene.

Leaves are painted with liquid soap and paint.

Cadmium yellow background is dabbed with smooth, natural sponge.

Foliage on small tree is stippled with dry pigment on a stiff bristle brush.

Rough bark created with liquid soap and paint.

Foreground shrubs blown through a drinking straw.

Traditional techniques

There is nothing new about using a variety of techniques in your watercolours. Those termed 'traditional' have, in fact, been used for centuries by artists wishing to replicate the textural richness of their surroundings. These are as relevant today as they were when the medium's early painters first surprised the viewing public.

Stippling with a stiff brush – one made of bristles is good – imparts very broken marks, ideal for textured backgrounds. This technique goes one step further than straight broken colour or dry-brush, and rougher variations can, and should, be exploited using household painting brushes, nail brushes, wire brushes, and so on.

Spattering has a unique way of unifying certain paintings with its finely unpredictable spray. It can be use to enhance mood when depicting water or perhaps conveying a misty or rainy day. Paint may be flicked with the thumb off any type of brush. With its stiff bristles, an old toothbrush is especially good.

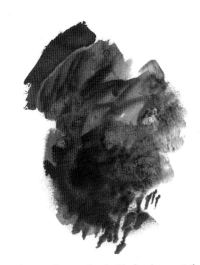

Soap is normally acquainted with cleaning up at the end of a hard day's painting. However, the bubbling lather of soap can be mixed with wet pigment to keep the strokes separate and distinct from one another. Ideal for weathered textures, soap thickens the paint and prevents it from moving too far on smoother surfaces.

Sponging using natural or man-made sponges creates a diverse range of marks from smooth to coarse, which are most effective when built up in layers.

Blowing through a drinking straw pushes fluid paint around, and creates spidery lines that run with the direction of the breath.

Non-traditional techniques

In non-traditional circles, painters are often led by their enjoyment of mark and surface, relegating subject matter to a secondary position of importance. When approaching your work this way, anything that disturbs the settling surface of a wash is suitable for creating effects. Keep an open mind when looking at possible techniques, and always investigate objects that might create an impression and be useful for replicating the shape or texture of a specific object. Here are some ideas to get you started.

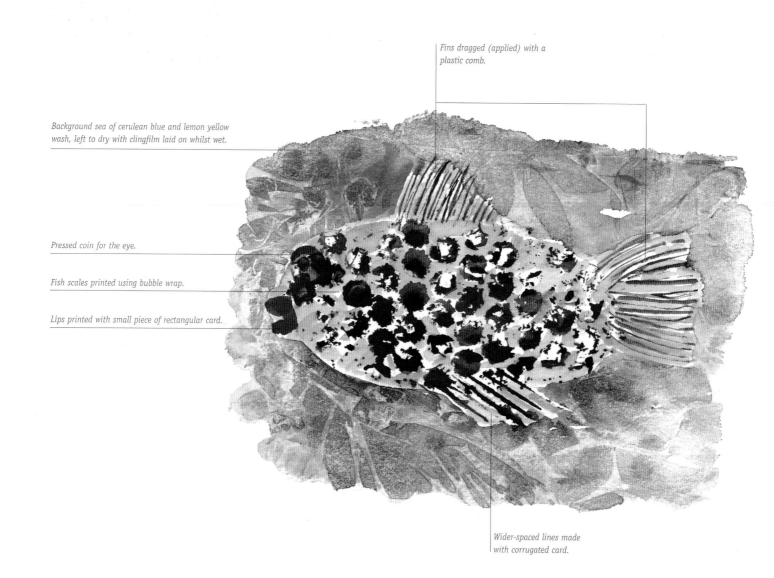

Fins dragged (applied) with a plastic comb.

Background sea of cerulean blue and lemon yellow wash, left to dry with clingfilm laid on whilst wet.

Pressed coin for the eye.

Fish scales printed using bubble wrap.

Lips printed with small piece of rectangular card.

Wider-spaced lines made with corrugated card.

Bubble wrap is a flexible film that is exciting and fun to work with. When this non-porous sheet is pressed into wet paint, pigment flows beneath and around the creases. When eventually the medium dries and the sheet is removed, the bubble wrap leaves uniform lines of dark, circular rings (above).

Clingfilm works in a similar way to bubblewrap and can be used to create even more original effects. When the paint has dried and the clingfilm is lifted, it will have left dark and light streaks (above and above right).

The streaky marks and creased lines in these clingfilm examples could not be made to look as natural by any other method. Their exciting variations make superb backgrounds onto which you can work.

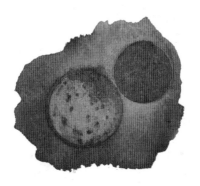

Cardboard and corrugated card are good brush substitutes, behaving much more like a stencil, allowing straight yet broken lines to be duplicated quickly and easily.

Objects with raised surface patterns or texture pressed into a wet, saturated wash leave a dark, printed effect, similar to etching. The paint should be fully dry before the object is removed. Alternatively, paint the surface of, for example, a coin, press it into the paper and remove when fully dry. The effect is like a pressed relief print.

Alternative mark-makers include dip combs, car scrapers and other domestic tools. Dip them into paint and draw with them to deposit multiple linear trails. Here a household plastic comb was dipped into a creamily mixed colour and dragged vertically to produce these striations.

Backruns and texture

As the techniques increase in complexity, you may feel a little out of control, or unsure that you will ever complete a picture successfully with so many processes and stages to think about. But uncertainty affects everyone who dares to experiment, and there is always a strong chance that things will not go as planned. You will learn to live with this and even come to relish the unexpected as your skills develop. If you devote a sketchbook exclusively to mark-making, experiments and techniques, you will not feel you are spoiling anything when things go wrong. Then, when you need to recreate an effect that worked in your favour, you can look it up in your own source book.

Textures

You should have noticed how motivating the experience of creating textures can be, and how quickly one idea leads to another. Textures can add real excitement to watercolours, but do not over-use them. Too many special effects in too small a space could result in a heavily over-painted and oppressive composition [1]. Try to keep a balance between textured surface and lightness of touch by limiting yourself to say, a maximum of three techniques in any one picture.

For textured mark-making involving household objects and materials, it is vital that you do not get impatient and try to remove objects from the paper surface before they have had sufficient time to dry. If a coin or piece of bubble wrap is lifted too soon, the technique will not succeed [2]. Similarly with clingfilm, the blotchy, creased stains can only happen when the wet paint is trapped between paper and plastic and the moisture is allowed to evaporate. Dedicating a working area specifically to textured paintings – a place where they can be left unhindered – is a good idea. While these pieces are drying you can be working on something else.

[1]

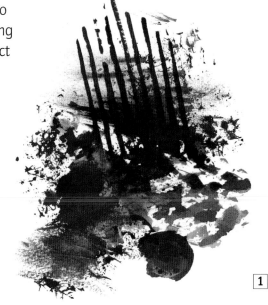

The swatch shows the mark left by a coin that has been removed too soon. It has not been allowed to make its full, strong imprint.

[2]

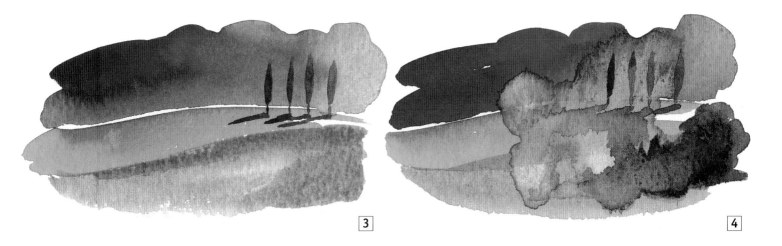

3

4

Backruns

These should be exploited with confidence wherever they can enhance the mood of a scene. Sometimes, however, they can occur without warning and in the wrong place, especially when the paper has not quite had enough time to dry completely. So when does a technique become a mistake, or vice-versa? You alone can make that judgement, but a good test is to consider how well it enhances the character and intention of the painting. As far as backruns are concerned, prevention is better than cure. Here are three simple rules that can help to stop them forming:

1. Always wipe away excess water held in the head of the brush before picking up paint [3].
2. Avoid working back into a wash that is not totally dry [4].
3. If you must modify an area, wait until the wash is either dry (for a hard edge), or almost dry (for a softer edge). If the paper has a sheen on it, then it is still too wet to paint on.

If an unwanted backrun does form, the situation can only be saved through rapid action. Lift off the excess moisture with a natural sponge to produce a lighter, softer shape [5]. Conversely, simply paint a darker shape over the top with a dry brush and thicker paint [6].

Occasionally, a linear backrun appears around the edges of a picture, particularly where a large wash has been laid. To stop this run-back of pigment and water, lightly stroke out over the edge of the paper with a clean, damp paintbrush or sponge.

5

The unintentional backrun in this blue panel has been softened by soaking the moisture up with a natural sponge.

6

Here, an accidental backrun has been 'repaired' by adding darker, drier colour directly on top. The three side strips show how effective the coverage is.

Masking

I enjoy masking techniques as they involve thinking through how a work will progress, allowing time and space to consider not only the compositional shapes, but also the various tints, tones and techniques that will bring the picture to a successful conclusion. Masking or 'stopping out' is simply another way of reserving whites (see page 40). However, instead of painting around drawn shapes, the reserved areas are covered with a masking agent – tape or rubberized fluid – and paint is then applied over the entire surface. When the paint is dry, the masking agent is removed to reveal clean, bare white paper with crisp edges. The method also protects any layers beneath, and deepens tones while safeguarding selected parts that you wish to keep light in tone.

TIP

Masking fluid can stain, so always do a test on a small corner of the paper first. Fresh fluid is less likely to stain. Once it has been opened, a bottle of masking fluid should be used up as quickly as possible, although no firm 'use-by' dates are normally advocated.

Whites are essential to the watercolourist, and you will probably have found that at times it is hard to retain them. The task of remembering where your whites lie, and trying not to go over the lines, can be exhaustingly restrictive; before you've even put brush to paper, the fun can be knocked out of painting. Here are some tricks of the trade that can make life a whole lot easier:

Hard-edged square forms of yellow ochre contrast to make the only 'solid' structure in the whole composition.

Soft dropped-in colour (see page 46) is used to produce the sky of cerulean blue with a little ultramarine to warm it.

Masking fluid stems and blooms are 'drawn' with the opposite, blunt end of the brush handle.

Soft, two-coloured wash is spread evenly over the masking fluid, with greater density in the foreground.

Masking tape is a pale-beige, adhesive paper tape available in 1, 1½ and 2 inch (25, 38 and 51mm) widths. It can be bought in all hardware stores, and most people are already aware of how useful it is in protecting surfaces when decorating. It is best employed for masking out straight runs of colour. Lay the tape firmly along the edges of the required shape.

Paint over the whole area, including the tape, and allow to dry thoroughly. When you remove the tape, you should have perfectly crisp edges separating white paper from colour. Tape can also be laid over a previous wash of colour, provided that the paint is absolutely dry.

Masking fluid is a yellowish, viscous liquid that is latex-based and dries fast. Its 'set' state is a semi-transparent rubber film that adheres to the paper surface, and is completely waterproof and watertight. Protecting your whites with masking fluid is a completely liberating experience as it allows gestural brushmarks to be used and spattered marks to be made – all with a definite solid edge. Masked areas drawn with a pen can be extremely finely laid. When both fluid and paint are completely dry, the rubber should be gently removed by rubbing the paper with your forefinger. If you applied the fluid with a brush or nib pen, this should be rapidly washed through with warm soapy water, or it will be gummed up and unusable.

Stencils can be made from cut cardboard and used to mask out solid shapes. Hold the shapes firmly in position and paint over and around them, using a dry-brush technique. When dry, lift the cardboard from the area that was covered to reveal crisp white shapes.

Fruit netting, such as the type used for containing oranges, can be cut open and spread onto the paper. Tape down the four corners and paint over the whole mesh. Be careful not to disturb this 'mask' or the patterned effect will not be defined.

TIP

Reserving whites with masking fluid gives a broken quality which is more natural and less rigid for plants and flowers. Do not overwork any additional colour that is added. Keep it fresh and alive.

Wax resist

Exploiting the waterproof qualities of wax provides an easy, clean method of producing whites with a particular textured surface. Based upon the premise that water and grease do not mix, a wash dropped onto drawn wax simply runs off to the untreated areas of the paper. Because the wax is not able to totally penetrate the dips in the paper's grain, a pleasing and distinctive textured pattern results. Unlike the masking techniques you have previously studied, wax will not protect a layer of paint underneath: instead, the wax itself becomes that lower layer.

The simplest solutions are often the best, and wax resist using a white candle or, if preferred, coloured crayon, can yield the most stunning results. The twenteith-century English watercolour painter Edward Bawden developed his own highly personal version of the technique by adding the heavy, brown, cobbler's wax known as 'Heel ball' into his pictures.

Wax resist can be used as an alternative to lifting out cloud forms in skies. In seascapes, it can be used in place of reserved whites to convey the glistening crests of waves. Its textural appearance also makes it ideal for describing the surface patterns of tree bark, stone walls or gravel paths, when worked in conjunction with layers of wet washes.

TIP

Plan ahead when deciding to use wax as a resist technique. Once this medium is administered, it is not easily removed.

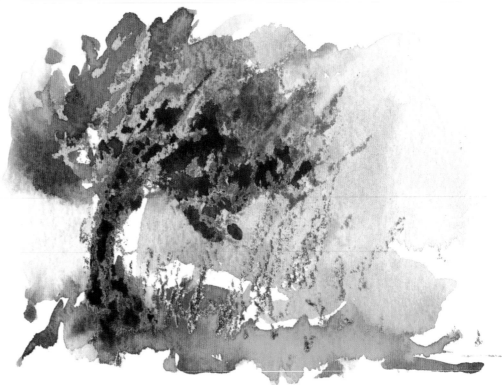

When painting a tree, the natural inclination is often to work in a controlled way with tonal layers to describe the canopy and selected smaller shapes to define the leaves. This example employs wax resist, used as a broad drawing implement, with strong-coloured washes repelling the surface to add leafy textures and a surrounding atmosphere.

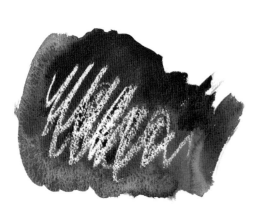

Take a wax candle and mark the parts of the paper you wish to resist, applying strong pressure. Vary the length and pattern of the strokes according to the effect you want to achieve. To see what you have drawn, look across the paper at the shiny wax reflecting the falling light. should be able to see the shiny surface of the wax reflecting the light. Next, mix up plenty of colour and apply strong washes across the resist area. As the paint slides off the waxy marks, the whites will instantly show up, creating a dramatic contrast with the paint colour.

Use the candle more sparingly to make sporadic gestures on the paper surface. The added washes vary in strength, setting up an interesting interplay between the resisting candle mark and the soft stains washing over them.

A wax crayon is more controllable than a candle and available in many more colours. The sharper definition of the squares demonstrates the level of control possible from a typical pack of paper-wrapped crayons.

Work two colours, one upon the other, to set up a lively 'dialogue'. A deep, contrasting wash brings the wax colours to the fore as resisting takes place. By working multiple layers of wax, you can produce an alternative to broken colour.

Oil pastels softly spread onto the paper are easier to control than wax crayons. These squares were fairly accurately drawn and a wash laid over the top. Great intricacy of mark is possible with oil pastels, and you can experiment with the building of multiple layers.

With finer control, these delicate lines are laid first in one diagonal direction, and then in another, much as you would cross-hatching. The result when the blue wash is added is of broken colour over the orange and red stripes.

Washing off and Scraping back

There is a technique to suit every possible visual phenomenon. When, for example, strong light catches a hard, shiny surface, the highlight can be fine and sharply intense, requiring something other than those techniques already recommended for masking and reserving. Scraping back, or 'scratching out' as it is sometimes referred to, is just such a technique. Its origins can be traced back to the revolutionary paint-handling of one of the finest exponents of watercolour, J.M.W. Turner. He exploited what he considered to be the best methods of replication for certain textures and effects, including pushing a blade into paper. These daring acts broke once and for all the notion of watercolour as purely a smooth, tinting medium.

Washing off

Colour can be removed from a sheet of paper by washing it off with water. When the paper is run under the tap, the main particles of pigment will be dislodged. However, there will always be a residue left in the grain, creating a soft stain and blurring any detail into misty hints of pale colour. Some artists enjoy washing off to such an extent that they use it at the opening stages of a picture, as it creates an interesting base from which to start.

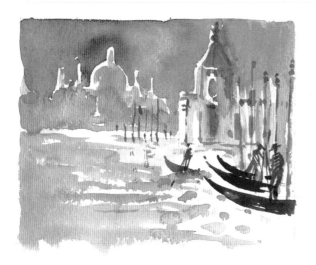

Washing off was used to good effect in this morning study of the Grand Canal in Venice. Running the study under warm, running water loosened the pigment enough to remove the surface particles, to evoke a misty mood.

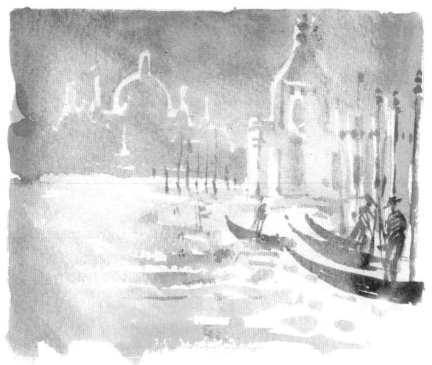

Scraping back

Lifting the surface of the paper is an easy and effective way to reintroduce those crisp whites to a fully worked watercolour. However, it gives quite a scratchy look to the picture, as the technique involves piercing the paper surface and lifting it away to reveal fresh white fibres beneath. This must be undertaken with a sharp blade on a totally dry surface if you are to avoid ripping the paper. Like so many techniques, it serves its purpose in a limited and specific way – for example, to show sharply reflected light on the tips of waves, or through heavy falling rain.

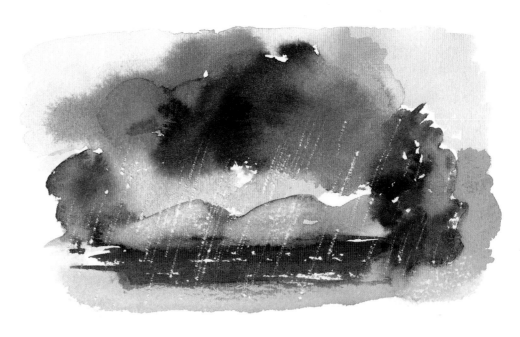

To convey the strong, diagonal rain bouncing off the water, a scalpel blade was pulled diagonally from top to bottom across the surface. Care was taken to scratch out only when the rest of the picture was fully dry.

Any knife blade can be used for this technique as long as it has a sharp blade and tip, although the ideal choice would be a scalpel or craft knife. Drag the knife point horizontally across the paper and feel the resistance as it gently gouges the surface. You should be left with a white, even line, which is slightly soft at the edges. Do not dig in too hard as you may well slice through the picture and have to repair its underside with tape. Heavier weights of paper are best for this technique.

To use a razor blade, hold the blade flat against the support and carefully pull it downwards until the colour is scraped off. Due care and attention is of the utmost importance when using a razor, as papers can be so easily scarred through mishandling.

Using sandpaper to remove colour will leave soft, textural, shaded patches. The diffused highlights that fine grades of sandpaper can produce are most suitable for bubbly highlights on waves or waterfalls.

Gouache and ink

A variation of washing off involves using gouache with Indian or permanent drawing ink. The design is painted in gouache, and the whole picture surface is then covered with waterproof ink. When dry, the design is held under warm, running water and the ink washes off where it had been applied on top of the gouache. The ink remains in the places where gouache has not been painted and the whole effect looks similar to a negative image or woodcut.

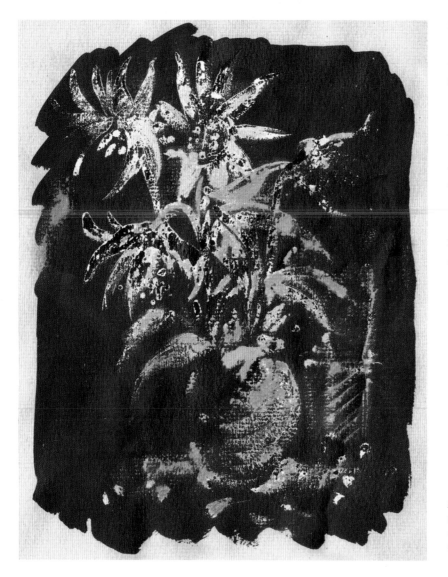

So that it does not buckle when wet, the paper used must be stretched onto a board prior to painting, and white gouache applied (coloured gouache could stain the paper and ruin the overall clarity of the image). Washes of fluid, black, waterproof ink are brushed over the gouache image and allowed to dry out fully. The application of warm water causes the ink particles resting on the gouache to loosen and wash away, revealing the image in stark contrast to the remaining black ink. The design can be either left as a black and white image or be re-tinted with hues of watercolour, ink, gouache or acrylic. This sequence shows a simple picture of flowers in a vase, and reveals the process by which it can be made.

Knowing how the properties of the two media work together, you can decide only to paint in the areas that catch strong light, allowing the blackness of the ink to contrast against the plant and container forms.

1 Stretch a sheet of tinted paper; in this case I used a medium weight (90lb, 180gsm) Ingres paper which has an interesting, horizontal grain running across it. Plenty of white gouache was mixed into a thick, creamy consistency and painted directly onto the paper. Using tinted paper enabled me to see what was being drawn.

2 Indian ink was applied to the paper in a couple of fluid layers. After the first layer had been completed, the design was still visible beneath. A second layer gave the necessary opaque covering.

3 Working across the paper systematically from top to bottom and from left to right, the vase of flowers was completely covered with patches of black Indian ink. At this stage, full drying time is essential to the success of the washing-off technique. I let it stand for almost an hour until it was dry enough to touch with fingers.

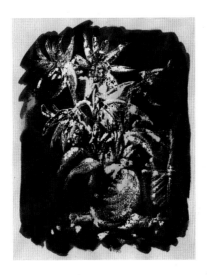

TIP

Indian ink is not kind to brush fibres. Wash them out immediately after use with warm, soapy water, paying special attention to the base of the hairs where ink can clog.

4 With a flat wash brush, the ink was repeatedly brushed whilst being held under warm, running water. The white drawing gradually became visible with repeated brush strokes. It is good to let some of the ink remain, as it shows up the grainy quality of its surface.

5 Finally the drawing was left to dry, one last time. At this stage you may choose to select areas to colour with soft, subtle tints.

Brush drawing

The work of Rembrandt reveals expressive drawings of figures and their surroundings, economically executed with a few brushstrokes and diluted ink, while English landscape painter John Constable recorded changing weather patterns with rapid brush drawings. Often used as notes for finished paintings, they nevertheless have much artistic merit. For centuries prior to this, Chinese and Japanese scholars pursued the potential of the brush as a holistic, spiritual art – a practice still taught and followed in the Far East today.

Working directly onto paper using a brush and watercolour, with no pencil underdrawing or outlines, is a rapid way of building confidence. It is therefore worth allocating plenty of time to this section because it will reward all areas of your artistic learning. Drawing with a brush will force you to think twice before making a mark, because it cannot be erased in the same way as pencil. The pace of your work will become slower, but more considered, and you will find yourself looking more and drawing less. The fact that a brush is soft and springy, allowing adjustments of pressure, means there is a great range of marks available to you, from fine point marks to flat 'moppy' washes. These marks are always dictated by the size of brush you use, the way that you hold it, and the pressure you choose to apply. Liberate your mark-making further by allowing your hand to move with the brush, releasing strokes of various pressures and strengths of hue, but do not concern yourself with reproducing recognizable subjects. There is no better way of expressing a sense of freedom and movement than through the power of brush, so get drawing now.

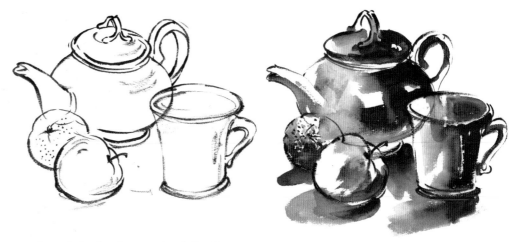

I practise brushwork on a simple still life, following the curves and edges with my eye fixed firmly on the subject. When I have ingested enough information, I take a leap of faith by swiftly laying definite strokes of the brush to describe the objects. I continue to look and repeat the same exercise until the whole group has been copied. An additional exercise can involve describing the objects with broad, tonal washes of diluted pigment.

Linear and tonal marks are the two main categories into which brush drawing falls. Try creating both types of mark with soft, round brushes [1,2], flat brushes [3], and a combination of the two [4]. Note how light pressure with the tip of the brush will give delicate, precise lines, and that by increasing the pressure this line gets thicker and heavier in weight. More pressure still brings the thick base of the brush into contact with the paper, resulting in a shaped stroke rather than just a line. You can achieve all these variations with just one brush.

Use tone and line together in a watercolour sketch to help create a sense of depth. The harder, linear shapes take prominence in the foreground, while softer tones recede into the background [4].

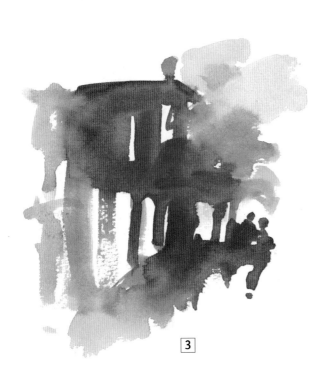

1

2

3

4

Line and wash

Very much an illustrative technique, line and wash can be traced back to the eighteenth-century British topographical watercolourists who, as they travelled around the landscapes of Europe, chose to accurately render the scenes they saw with fine penwork, enriched with tints of translucent colour. The method is well suited to small delicate themes, such as plant sketches and the recording of life in specific places. To date, I have amassed over 70 pocket sketchbooks, and most of my travel notes are contained in them as line-and-wash or brush-drawn studies.

The ink used for this line-and-wash landscape was deliberately non-waterproof so that individual lines would break down and run into the applied watercolour washes, giving the whole sketch a blue moodiness. Where definition was important to explain the situation – with the figures and larger rockfaces – wash was applied first and, when dry, a crisp line added.

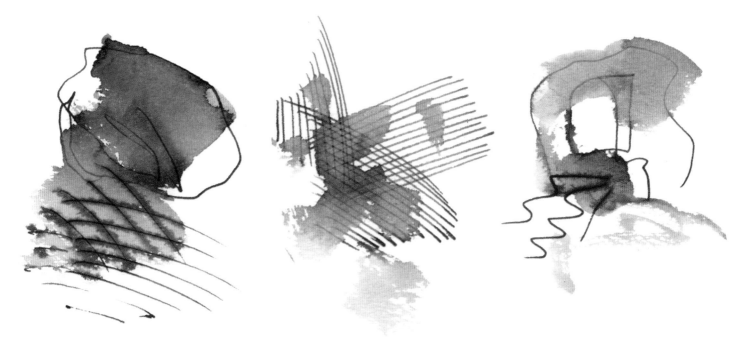

Wash with line is a valid alternative to line and wash, and encourages greater freedom in your drawn expression. Maintain immediacy, and do not be tempted to draw back into lines that may have run into the wash. Holding back will keep your work fresh and alive.

Line with wash can make use of both waterproof and non-waterproof inks. Draw lines with the ink, then drop wet watercolour into them when they have dried. The choice of ink will make a significant difference to the final result.

Brush line on wash offers a more fluid treatment than that possible with lines drawn with a pen.

Bamboo pens will add a much thicker, blunter line to the drawing. Experiment with alternative pens. Sharpen a short stick of bamboo, and saw a small split down the centre of the nib to act as a reservoir for ink.

Pipette-style droppers, of the kind used as lids on some ink bottles, provide an interesting alternative to pens, but are thicker and less controllable.

Water-soluble pencils

A particular memory is as clear in my mind today as it was back in the mid-1970s, when my mother came home from the adult education art class, clutching a small, flat tin, as a gift for me. In it were twelve coloured pencils and a small round brush. But these were no ordinary pencils: they were the very latest thing. 'Just add water', she said, 'I've seen them being used and they're wonderful.' The colours were treasured, exploited, washed and smudged into villa views on family holidays to Majorca, or in my room at home, where I copied pictures from encyclopaedias. While sorting out my studio the other day, I came across the tin, with its much-reduced contents!

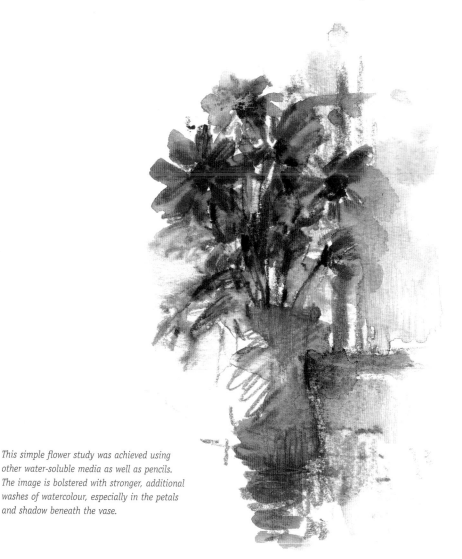

This simple flower study was achieved using other water-soluble media as well as pencils. The image is bolstered with stronger, additional washes of watercolour, especially in the petals and shadow beneath the vase.

Water-soluble or aquarelle pencils, as they are sometimes known, offer the controllable advantages of coloured pencils, but with the extra luxury of being able to loosen the lead with water and spread the colour as pure, thin washes. Although you can apply the colour in the same way as you would any other pencil, the temptation to moisten with a soft brush, damp sponge or finger will always get the better of you as you fall in love with the subtle possibilities of this medium.

Once washes are dry, you can work on top, building richer-coloured layers and strong linear detail. Again, you have the choice to add more water or leave the colour dry. Dampening the paper first will give your pencil strokes a softly bled edge, and this in turn is the perfect mixer for felt-tip pens, pen and ink, pencil and watercolours.

Overall, water-soluble pencils are a highly flexible medium, appropriate for rendering natural subjects and as handy in your sketching kit out of doors, as they are in the pot on the shelf in the studio.

Linear strokes can be softened with added water.

Lightly hatched pencil strokes blended to a smooth texture with a clean, wet brush. You may need to practise this to attain the correct balance of water to produce the quality of a watercolour wash.

Multiple layers of colour can be built up, then dissolved with water to create a rich, grainy texture.

Pencil tips dipped into water create a line that begins broken and soft, but quickly firms up into a solid line as it dries.

Broad, soft tools, such as sponges or a wetted finger, can be used to soften pencil marks.

Oriental brushwork

Many different styles of painting exist, all reflecting different philosophies, but what unites them all is that they capture the essence of a scene, gleaned from direct observation and based upon years of devotion to the skill of rendering trees, rocks, clouds and so on. Such a distilled approach to looking and drawing meant that in time artists could recall these observations with amazing accuracy from memory, as though present before their very own eyes.

The delicacy of this Chinese-style landscape was achieved with light, moppy washes pressed over the paper surface. The fine lines were painted with the same brush brought to a fine point, held out vertically at elbow's length, and drawn from a rigidly positioned wrist. Poised to paint under these restrictions will force you to deliberate every mark, an approach that requires undivided concentration.

The objective of the hsieh-i Shanghai painters of the tenth to thirteenth centuries, who concentrated on natural themes, was to 'write the meaning', that is, draw attention to the significance and substance of things through loose, calligraphic brushmarks. With this style came freedom to explore personal attitudes through imagination, thereby revealing a far more direct feeling for life. Later, when it became fashionable to collect silkscreens and scroll wall hangings during the latter part of the nineteenth century, the influence of Chinese and Japanese prints and watercolours became considerable.

Watercolour painters, in particular, can gain valuable guidance from studying the work of these masters of their craft. You might like to make a copy of an admired oriental watercolour or ink drawing to learn about methodology. When practising your brushmarks, allow plenty of time to deliberate over your strokes so that they are laid with thought and care.

Traditionally, a dry pigment ink with a brownish-black matt finish is used with Chinese brushes, but watercolours and bottled inks work equally well, albeit with a little more fluidity. As to supports, any fairly smooth paper is suitable – cartridge, hot-pressed or, if you feel ambitious, a sheet of rice paper, silk or Japanese handmade tissue. (Bear in mind that the latter two suggestions are highly absorbent.)

Inexpensive Chinese brushes *are set within a bamboo handle, and their densely packed, soft, absorbent heads are normally made out of hog or goat hair. Their extreme springiness means they are capable of both very fine and heavy expression within the same stroke, but sensitive control is necessary to achieve this.*

Japanese brush-pens *are cartridge-refillable pens that are ideal for small sketchbook work. I carry one with me at all times and use it almost exclusively in my pocket book. The ink dries in a matter of seconds, which is a great asset to the locational sketcher.*

TIP

Why not keep a Japanese brush-pen with you when out and about sketching? The special pigment ink will give you a fast-drying alternative to Indian ink or paint, for those times when you need to capture the essence of a pose or scene and then move on rapidly.

A Japanese brush-pen and dry pigment ink *was used to draw this branch in bud. Cadmium red watercolour was washed in with a medium-sized oriental goat-hair brush.*

Oriental brushwork *finds a perfect subject in bamboo. The dry ink is highly effective in depicting the natural textures of the canes and the long, folding leaves.*

Mixed media

Watercolour is a medium that mixes very well with others, offering numerous opportunities for artistic expression. It is important that different media have a common base, however, so that they can merge and blend into a whole, while simultaneously displaying their individual characteristics. Pastel, gouache, acrylic, pencil, printmaking and collage all have this unifying quality. For a mixed-media composition to be successful, certain considerations need to be followed. Adopt a method with a set order of working; for example, lay larger washes first before adding smaller details on top with, say, swatches of coloured paper. Use the full variety of media available and look to contrast the qualities of each in your design. Finally, keep a close eye on colour balance or imbalance and textural contrasts.

Gouache and watercolour complement each other well in opaque, semi-transparent and transparent applications. Thick, chalky pigment used on a hill or building can set up strong illusions of depth when painted next to contrasting, thin washes of a sun-bleached sky. By combining the principles of colour theory with paint textures, these contrasts can be heightened still further to bring about some startlingly luminous spatial effects.

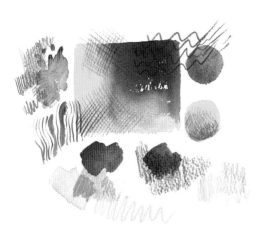

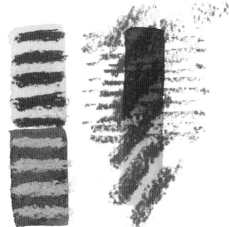

Watercolour washes overlaid with coloured pencil hatching on a textured surface can produce a lively image with a great sense of light. This has much to do with the two-tiered structure of the painting. The crumbled pencil lead caught on the raised grain of the paper creates a broken texture through which underlying wash can be seen, reflecting back the light.

Combining complementaries in the different media creates spectacular effects.

Watercolour over pastel achieves a less luminous result. The powdered pigment will partly resist the water, but some granules will be carried over the surface, producing a more solidly opaque and gritty texture.

Turpentine and watercolour is a combination based on the principle that oil and water do not mix. Drop a loose wash onto the paper and then dip the brush into turpentine and paint into the wash. At first the turpentine appears to mix, but as you increase your strokes, the marks will become more scratchily textured.

Alternatively, wet the paper in advance with a clean brush and turpentine, and paint watercolour over the top. This will produce a streaky, bubbling effect excellent for creating the illusion of movement across sea, sky or land. White spirit is a good turpentine substitute.

TIP

Try not to overuse pastel. Too much can kill the airy lightness for which the technique is admired.

Pastel over watercolour perfectly complements the sparkling character of the paint medium. Both break over textured surfaces, leaving virgin white paper to reflect the light. To start, a wash is first laid over the surface of the paper – ideally one with a strong grain. When dry, pastel is applied. The underlying wash shows through the crumbled pigment, giving the picture a glowing base. Like a brush, the pastel stick produces thin strokes at its tip, and wider strokes from the side.

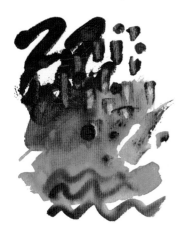

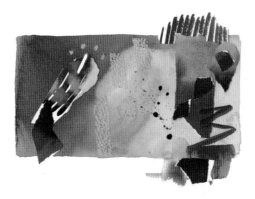

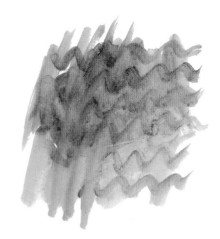

Acrylic and watercolour combine well because both are water-based. When diluted, acrylic is used in the same way as watercolour, but its behaviour is very different when applied straight from the tube. Drying to a plastic skin, acrylic becomes impregnable to any water-based substance, so it is important to thin it for use with watercolour. However, the contrast of thick, saturated impasto (unthinned acrylic), and flat, transparent washes works well in landscapes and rocky, textured objects.

Collage and watercolour uses everyday materials that are cut and stuck to prepared grounds in the place of paint. Where paper and fabric are chosen, watercolour becomes the perfect staining medium. As layers are built up, gouache can be added to evoke strong spatial effects. When working with collage, your guiding force should be an intuitive sense of colour and juxtaposition of strong shapes.

Acrylic gel medium accentuates the strokes made with the brush, and has the added advantage of drying back transparent, thus making it ideal for layered work. Be aware that as it is intended for use with acrylic, gel can be unkind to watercolour brushes, and they should be washed out immediately after use.

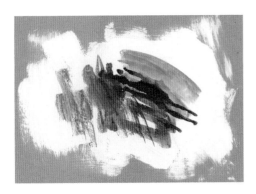

Gesso is another acrylic medium, and makes the surface of the paper impermeable, preventing the absorption of watercolour. Where gesso is applied with thick, definite strokes or patterns, the addition of watercolour produces interesting, grainy textures.

PVA glue and watercolour can create interesting linear, relief effects. Apply spots of glue or draw lines directly from the tube or bottle. For a more broken finish, paint it on with an old stiff brush. Allow it to stand aside to set (overnight is best) and, when completely dry, run washes over the raised marks you now find. The PVA ridge may pool the paint and cause puddles to form between glue lines, but do not be concerned – it is all part of the technique. Unlike masking fluid, do not attempt to remove glue lines when dry, as this will destroy the surface of the paper. Glue should never be mixed with your paints as it will ruin your brushes.

Masking and reserving

It is very common for artists of all levels and abilities to experience difficulties from time to time, and it is especially beneficial to discuss them. Having worked through variations of resists and seen first-hand their effectiveness in producing instant whites, now is the ideal moment to consider why things may not quite have worked out as you had expected.

Masking fluid

I sometimes find that the adhesive properties of masking fluid, when dry, are too strong for some papers, and the removal of the rubbery gum rips the surface. This applies especially to those which are smooth in texture (hot-pressed), or softer and more absorbent (handmade). Should this happen, do not panic! If the area was white, you can soften the fibres of the paper back down by very gently rubbing them with a soft eraser.

To replace colour you have two options depending upon the severity of the tear. You can paint back over the rip with a very dry brush, building up paint layers with the cross-hatching technique. If the repainted surface is considerably darker, you may like to add a little white gouache to the mix to unify the tones [1]. Re-build the paper with a crust of gouache formed of thin, creamy layers of pigment. Try to apply the paint as smoothly as possible.

A dry option might be preferable. Use watercolour pencils (not too sharp) to draw the missing information back in and, where appropriate, blend them by dampening the pencil with a moist brush [2]. If you feel that the surface will not be able to take it, then just leave it dry, so as to avoid causing further damage.

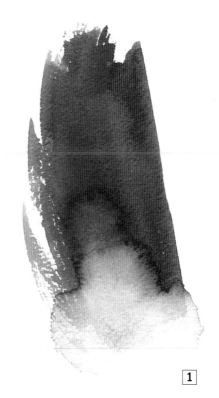

The paper has torn inside the flower design. The examples around the edge show how the repair would look using cross-hatched watercolour pencil.

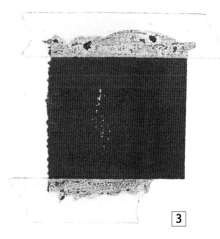

Masking tape

Masking tape is available in different adhesive strengths. The low-tack form is probably most suitable for watercolour applications as it peels off with relative ease. Make sure that you press it firmly onto the paper surface when you wish to create a hard line. If a seal is not tightly made along that line, wet pigment can seep under the tape and form a soft, bled edge [3].

Occasionally, a paper surface may not take too kindly to the removal of tape and will rip. Wherever possible, try to have a small tester piece at hand for preliminary trials. Always lift the tape gently, slowly and with even pressure, pulling it carefully along the paper until it is all removed. If the paper does tear, follow the same procedures as for masking fluid [4].

Half a fingerprint has been corrected with darker paint.

Accidental grease resist

Resist techniques – using wax or grease to repel watercolour – can produce some great effects. But depositing an unintentional resist is so easily done through the brush of a hand or arm upon the paper surface [5]. Prevention is always better than cure. Try to keep your hands clean and washed in soap, and get into the habit of leaning on a scrap piece of paper. Handle new paper carefully, and grip it lightly at the edges between the tips of your fingers. Depending on the surface, hand grease can be covered with a few applications of colour [6]. Bockingford NOT paper responds well to this rescue treatment.

Removing colour and scraping back

It must be stressed that these are both valid techniques for intentional highlighting and softening of pictures, but at times they can also be used to rescue pictures that have gone wrong. Gentle scraping of the upper surface of the paper with a new scalpel blade or razor will successfully remove small areas of colour or fine detail [7]. However, this technique is not suitable for the removal of larger areas. Colour can also be removed using a medium plastic eraser, rubbed gently in one direction.

Flooding the area with water and gently mopping off with a sponge, kitchen towel or suitable brush can also wash away unwanted colour, although some staining will remain.

Making pictures

Getting inspiration indoors

Almost any scene or object is a potential subject for a painting, so you do not need to look very far to find inspiration. Home is always a good starting point. We so often take the interior world for granted, but it makes a fascinating topic for watercolour study, offering a cornucopia of colourful delights in an infinite array of shapes and patterns that do not even require you to go outside. Beginning indoors also provides you with the space and privacy necessary to build confidence in your abilities.

Windows provide us with naturally framed compositions, and the spaces in between furniture and ornaments create unusual shapes to paint. There may be 'inner worlds', too – spaces within spaces, such as a drawer full of humble, domestic objects. Consider the round and pitted fruits in a bowl and the fronds of leaves as they contrast against chairs, tables and soft, patterned, upholstered sofas. All have structure, shape, colour, pattern and texture and can be seen from numerous viewpoints.

Animals and children are innately curious about their home surroundings as they hide in cupboards, peer through banisters or look up from the level of the carpet. Why not follow their lead and view the interior world from more adventurous and extraordinary angles? As the varying intensity of the sun during the day gives way to the muted yellow of artificial light as darkness falls, also take into account the way in which this affects colour, definition and contrast.

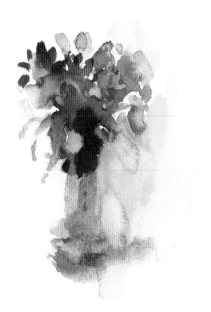

Be reinvigorated by fresh, spontaneous approaches to fruit and flowers.

Still life

Still life is a long-established genre that continues to provide artists with the inspiration to develop their drawing and painting skills, encompassing all the typical problems, including how to render form, colour and texture, how to express the spatial relationships between objects, and how to achieve a balanced composition. The seventeenth-century Dutch painters, who were masters of the still life as well as other indoor subjects, refined the discipline with sensitively handled and complex arrangements of soft fruits set among the hard, reflective surfaces of bowls and pitchers. Their emphasis was on capturing the realism of the setting through glazes of radiant colour. By the late nineteenth century, when Impressionism and a fascination with light had superseded realism, the still-life watercolours of Paul Cézanne struck a more vibrant chord in seeking to convey solidity and depth through strong colour contrast.

To arrange your own still life, choose a few simple objects that excite you because of their surface decoration, texture or colour. A juxtaposition of natural forms such as fruits and man-made items like dishes is a good idea. Strongly patterned tablecloths provide a good base for unifying a group of different objects. Your grouping should be as natural as possible, and tonal variation and contrast strong, to emphasize spatial depth.

'Found' life

Within each room there are inanimate worlds just waiting to be discovered and painted. Open any sideboard drawer or cupboard and you will find a readily selected and composed grouping of objects. Cutlery, stationery, books, writing equipment and other ephemera all make interesting subjects, especially when they are cropped and scaled into fixed parameters on your drawing paper.

Choose your subject from a larder cupboard, shelf, drawer or other suitable container, and lightly sketch in the main shapes of a few selected items that you find there. Remember to consider the scale and contrast as key pointers to the successful completion of the painting. Build up the picture with tonal washes and exploit the full contrasts of dark and light as you see them.

Most of us have a drawer like this, making it the perfect subject for a painting!

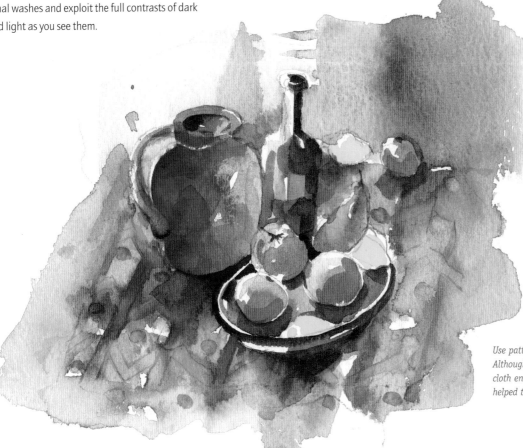

Use patterned cloths to enhance still-life subjects. Although barely visible, the strong pattern on this cloth enriched the colour and tone of the painting, and helped to harmonize the various hues of the subjects.

Getting inspiration outdoors

Now that you have gained confidence through working indoors, venture over the doorstep into the outside world. The watercolour tradition has always strongly featured landscape and seascape as inspired subject matter, and the constantly changing light and natural elements make these subjects perfect for the portable medium of watercolour. Painting out-of-doors is a very engaging pastime; the vitality of paintings made here can be hard to recreate in the relative comfort of the studio, where the urgency to record the fleeting moment is just not present.

TIP

Ensure that your landscape subject has enough elements of interest. A tree, fence or road can make a good lead into a painting, and objects that suggest life, such as farm machinery, a barn or rural dwelling, can offer a focus. Distant grazing animals are also good for breaking up wide, open washes of colour.

When seeking inspiration outdoors, begin gently – a quiet and familiar place is good, in a corner of the garden, for example – then, as you successfully meet the challenges, increase the difficulty of the subject. Keep looking all the time and consider every view as a potentially interesting topic. Always remain curious, turn new corners and expect to be inspired, especially when visiting other cultures, and remain ambitious: don't just stick to doing what you know you do well. Seek the extraordinary in the ordinary – rooftops and scrapyards are just some of the unexpected outdoor subjects that can provide the raw material for fabulous watercolours.

Landscape

Rolling plains, steep mountain valleys and dense, shady woodland all make inspiring topics for landscape paintings. In the eighteenth and nineteenth centuries, it was common for artists to travel across continents, recording the exotic locations of distant lands. Long before the invention and convenience of cameras and camcorders, sketches were an accepted necessity for a traveller's records, and a whole genre known as topographical painting was born.

Landscape still provides huge inspiration for practitioners the world over, and its ever-changing nature supplies fresh stimulus on a daily basis.

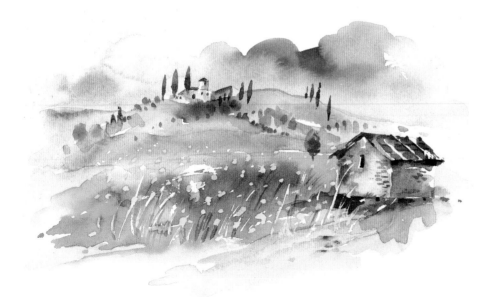

The rural Italian landscape displays a variety of exciting features in its rolling hills, rough stone barns, swaying grasses and towering, pylon-like cypresses. The barn in the front of this picture provides a focus, and masked-out grass stems add a foreground layer of texture.

City and townscape

Observing life in the bustling city is the hardest of all. Vehicles race past and people move quickly by in their daily routines, but there is a lifetime's worth of study in this subject alone, and the constantly changing scene will not allow you to get bored. Admire the eclectic shapes of buildings and colourfully clothed shoppers, or simply watch the world drift by from a café table; it is a ready-made easel, from which you will never be short of visual material. Where structures have strong, definite lines, people may be delineated in soft washy passages. Trying to paint moving life is a good test of visual memory, and you should keep your mark-making direct and simple, focusing perhaps on just one aspect, such as colour or shape. It is the essence of a scene that you should be trying to capture, and this requires an uncomplicated treatment.

Weather

Changing weather patterns can provide a stimulus for defining mood and atmosphere. The English painters William Turner and John Constable spent much of their time recording the effects of light as reflected in the clouds, while European Expressionists, such as Emil Nolde, asserted the growing angst of their life in the twentieth century through the vehicle of climatic change over land and sea.

Visit a favourite spot, preferably a landscape or seascape setting, and profile the changes in weather as observed throughout the day or, if it is more appropriate, over a number of days. Use a limited palette, large flat and round brush, and suitable techniques, from the earlier section of the book.

Seascape

This is always a favourite source of inspiration, especially in the warmer summer months. From wild, rugged coastline to populated bathing resorts, seascape has fond associations for many and the practice of watercolour sketching is very therapeutic. Changes in sea, sky, boats, quayside activity, sunbathers and holidaymakers at play will all supply you with an endless stream of ideas.

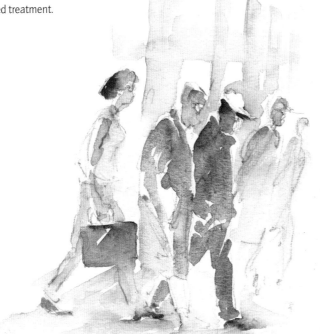

Speedy brushwork over sketchy pencil marks creates the illusion of movement as figures pass by.

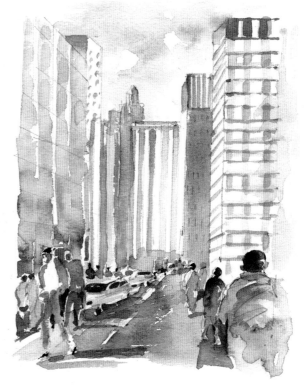

Simple fluid washes over rapid pencil lines were most appropriate for describing the fast pace of the city.

1 | *Sap green splodge denotes overhanging tree. Only the basic shapes of buildings sketched in.*

2 | *Breaking down a scene into three bands of colour: sky (ochre/neutral tint), sea (ultramarine blue) and huts (sepia).*

3 | *Looking at contrasts – new apartments contrast with old house.*

Traveller's notes

Sequential painting

Travelling on a bus or train, when away or during a normal day, may well provide plenty of spare time for inspiration. Documenting the stages of a journey can be a highly satisfying and productive activity that will provide a memorable visual log to complement notes and snaps – indeed all three elements can be included in the same sketchbook.

16 | *Final image smudged by hand – a mistake which curiously does not ruin the whole.*

A good way to get started in the area of travel sketching is to follow a planned task, with set time limits and a realistic expectation of the final outcome. Frequent stopping and starting, curious fellow passengers, and the constant movement and noise can all be very off-putting; in such circumstances all you can aim to produce are fleeting sketches.

I devised the exercise here as a watercolour record of the view from a train window as it moved along England's south coast. The excursion had a total of sixteen stops and I decided that I would make a sketchy watercolour note at each station stop but only for the duration of that stop – about two and a half minutes in each case.

I began by creating a light pencil grid with

15 | *Stark and simple: school buildings simply drawn in sepia and viridian.*

14 | *This stop at Lewes was very short and execution was rapid. Resisted temptation to add to it later.*

13 | *Wet-in-wet study of tractor in front of the Downs, barely achievable in the time I had.*

12 | *Key to the signal is red. This alone describes it.*

4 | *Suburbia in viridian, cerulean blue and burnt sienna. Feeling forms with flat colour.*

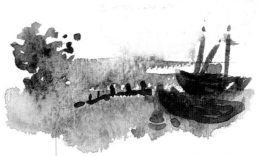

5 | *Land meets sea as expressed through symbol of beached boats.*

6 | *Exclusive properties fenced off. Fence gives depth to the composition.*

7 | *Pevensey Castle was a struggle to draw. Daubs of sap green and neutral tint are an economical impression.*

8 | *Uniformity and repeats of pattern as seen in terrace using Indian red and viridian/sap green mix.*

sixteen boxes to fill, and made notes to each sketch as I completed it. In working under such tight restraints I knew that the work would retain a fleeting freshness and that I would be forced to seek out the singular most important aspect of each place. This is one of the real benefits of this type of exercise. Because there simply isn't time to get into detail, you are forced to work quickly and spontaneously, which is an excellent way of learning to loosen up. And if you find fellow passengers inhibiting, put a little physical distance between you – move to another seat, if possible, or place your bag so that it blocks their view of what you are doing.

Working tips

- Carry two screwtop water pots, one for clean water and one for waste water.
- Carry a small watercolour box (twelve colours maximum), with an attached mixing palette.
- Use no more than four colours.
- Work directly with a broad brush, without drawing first.
- Allow the movements of the vehicle to dictate the marks you make.
- Keep sketches small.
- Keep order in your workspace.

11 | *Fence picked out after study done, but this time as a device to focus the Downs.*

10 | *Sense of movement portrayed through loping figures suggested by quick paint marks.*

9 | *Complex forms of Victorian station massively reduced, but still recognizable. Column style and colour are clues to identification.*

Composition

Composition is the arrangement of elements within a picture, and determines both its aesthetic qualities and what it communicates to the viewer. Several theories exist to explain the nature of composition. However, it is probably best to follow the instinctive, unwritten rules, based on observation, that pictures without total symmetry tend to be more pleasing and generally more eye-catching.

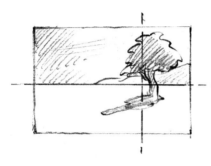

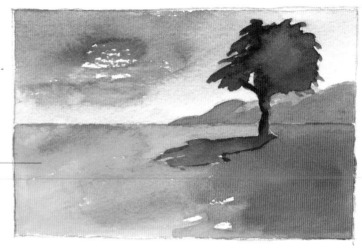

The first study is one of several options for a composition based on the 'thirds' principle. A horizon line cuts through the centre, separating land from sky, while the right-hand third of the picture area is occupied by a tree which neatly balances the background hills directly behind on the horizon. The open space to the left allows the eye to focus on the tree with no distraction.

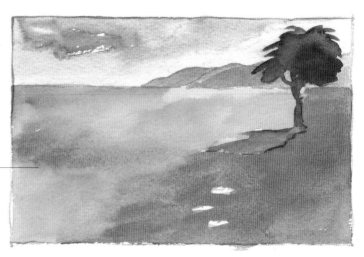

Here, the horizon has been placed further up, forcing the sky to occupy just one-third of the picture area. The change is staggering. The land draws the eye up through the front of the composition and over to the right-hand third, where the tree and hills are placed. The high horizon creates a far greater sense of openness and space, and the tree has less overall impact than in the previous study.

Good composition is defined as shapes, forms and colours all working well together to present a unified and dynamic whole – one that has impact and holds the viewer's attention. I tend to work on the 'thirds' principle, which balances the elements within a painting on a one-third to two-thirds basis.

Let me explain. Total symmetry often looks static and uninteresting to the eye. Compositions appear most balanced when the objects of primary focus fall within one third of the painting area, leaving the other two-thirds to play a secondary, and often less busy, role. By dividing your watercolours into three different planes, you will find yourself automatically following the unwritten rules of composition. The examples below demonstrate how this works.

Each painting is made up of the same four, simple compositional elements: a tree, background hills and plain sky in a flat landscape. By choosing complementary colours, I have emphasized the bandings of the picture planes, to make them clearer to understand. The four thumbnail sketches have been marked with horizontal and vertical lines to indicate the division of the picture area.

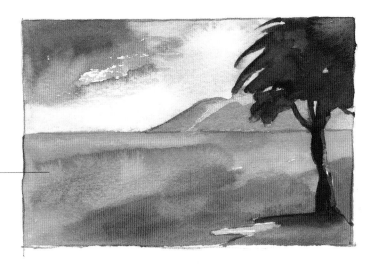

The horizon has been dropped back to the centre plane. This time, however, horizon, land, sky and hills are dominated by the enlarged tree looming over the whole of the right-hand third – a device which suggests a viewpoint from within the branches, and creates a particularly dramatic effect.

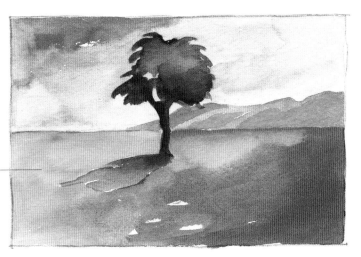

A central focus need not necessarily be a dull one: rules can sometimes be broken to great effect. Here the tree has been placed in the middle of the picture, dividing it symmetrically and creating visual conflict between the two balanced sides. The eye moves from side to side, but rests for longer on the busier right-hand half.

Western and Eastern composition

Since the fourteenth-century Italian master Giotto di Bondone – better known simply as Giotto – first fathered the idea of realistic, architectural space by placing figures and objects in scale according to their relative distances from one another, we have accepted the principles of perspective as being the correct rules for figurative painting. This has undoubtably influenced how we see three-dimensional reality as a linear progression from current into distant reality, with diminishing importance the further it recedes. But there is no reason why we should adopt this perception of reality, believing that what our eyes tell us is the full interpretation of reality.

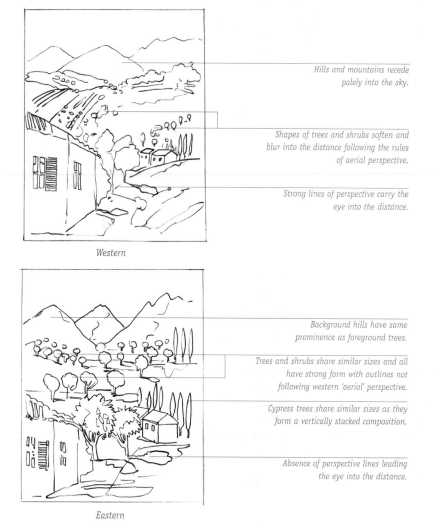

Hills and mountains recede palely into the sky.

Shapes of trees and shrubs soften and blur into the distance following the rules of aerial perspective.

Strong lines of perspective carry the eye into the distance.

Western

Background hills have same prominence as foreground trees.

Trees and shrubs share similar sizes and all have strong form with outlines not following western 'aerial' perspective.

Cypress trees share similar sizes as they form a vertically stacked composition.

Absence of perspective lines leading the eye into the distance.

Eastern

The Chinese and Japanese painters had quite a different theory that explains much about the format and approach of their art. Being long and rectangular in section, the Chinese scroll demands an artform that can be experienced in time as the eye moves across it from right to left, instead of following converging lines to a centralized vanishing point as with Western perspective. So individual motifs – trees, temples, mountains – all have their own focal points in the composition and have to be viewed in sequence. According to this principle, it is possible to 'travel' through miles of landscape – to follow a road from beginning to end, because both are prominently shown, or scale the highest peaks or plumb the depths of a river, all of which are given equal emphasis in the pictorial composition.

The Chinese watercolour painters produced these pictures from memory, gleaned from their experience of the landscape and an understanding of the laws of nature, which had been written 'on their hearts'. Thus they were able to travel through time and space simultaneously, following the path of their very own visual creations.

The Western view

The landscape shown has typical 'aerial' perspective, defined by the use of strong, warm colour to focus attention in the foreground, with cool pastels receding into the background. Reality here follows the rules of perspective, where the elements nearest to us are larger and closer in 'time' and 'space', while those progressively further away converge to a vanishing point, creating the illusion of spatial depth.

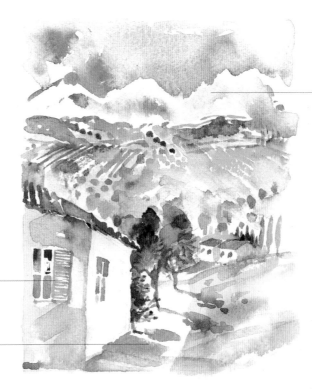

Soft edges on mountains prevent clarity.

Foreground colours are bright and warm.

Eye led along path by house in foreground towards dwellings in the middle ground.

The Eastern view

Using the principles of Eastern painting, the same picture has been recreated with no spatial distance. Here, all the elements are of equal size, and have equal importance. The focus is now where the eye wants it to be, and only moves across a single picture plane. Space ceases to be the major determinant in this picture.

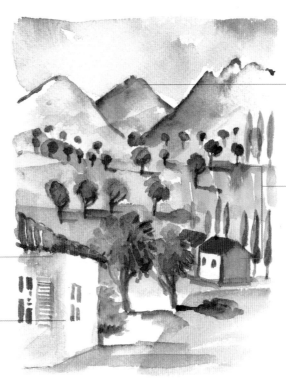

Hard edge delineates mountains.

Similar size for all elements.

Foreground colours are bright and warm.

Eye is led in by house in foreground, but picture no longer follows the true rules of perspective.

Getting a balance

Successful composition involves designing your pictures in such a way as to give them cohesive order. Placing the elements according to the principles of good design is important, but this must be combined with your own intuitive judgement. The latter sense is the part that ultimately makes the final decision – we tend to 'know' whether or not something looks right or wrong. We have already considered how to divide the picture area into thirds to set up the basic structure, but the various lines, shapes, colours, tones and textures must all be assembled together with great care to maintain the interest in a composition.

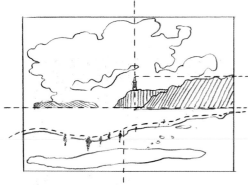

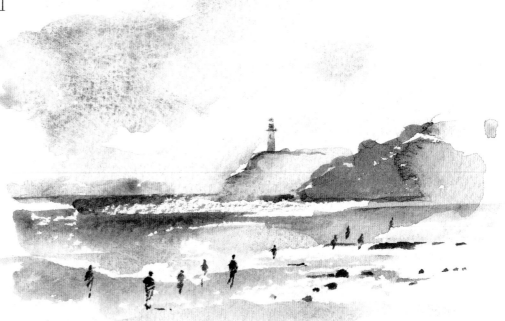

This simple, sparkly landscape – executed using the dry-brush, wet-in-wet and wet-on-dry techniques – has a strong, underlying balance of elements, as shown in the keyline diagram above.

Asymmetry

When a composition is based on a perfectly equal arrangement on its left and right sides, top and bottom, it has balance through symmetry; but this is not always the most interesting solution. If the elements are arranged so that part of the picture is more busy and 'active' while another area is more empty and 'passive', the composition will still have strong equilibrium through these new dynamic tensions. Compare this idea with a pair of traditional kitchen scales. A selection of different fruits might weigh the same as a small, yet heavy weight, but because it is 'counterpoised' the scales balance perfectly.

This assymetrical composition has emphasis and detail 'top-heavily' placed to the left. The space on the right leads the eye to the detail focus of the picture.

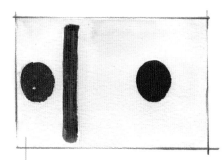

The asymmetrical elements of composition, broken down into abstract form.

Negative space

An object is painted which crops tightly into a rectangular format. The shapes that are created between the edges of the object and the edges of the paper are known as 'negative spaces'. These negative spaces are also formed in the gaps between different objects within the boundaries of the picture. Both are important to the overall look of the composition, and sometimes it is the negative spaces that create a stunning composition that entices the viewer in. In a representational picture, the composition can be also translated into an abstract arrangement of coloured shapes.

This simple study of pears focuses on their positive shapes.

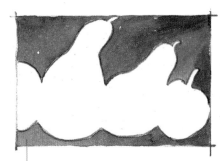

The negative spaces formed by the positive shapes of the pears.

Rhythm

The way elements move within a composition can help to balance it. Repetition of colour, pattern and mark work in much the same way as structured beats in music, giving the piece a distinctive mood and flavour. This effect is known as 'rhythm'.

This study has a snaking rhythm cutting diagonally along the shoreline.

Contrasting marks and colours make rhythms.

Appreciating abstracts

I have heard so many people dismiss abstract art in throwaway comments like 'my three-year-old daughter could do better than that!', and in so doing, are more often than not responding to an image at face value; vocalising their distaste about a subject for which they have little or no understanding. It is perfectly acceptable to not like a picture, and without such varied creative interpretations the world would be a very dull place, but some explanation as to why artists take the route of abstraction is helpful to gain an appreciation.

Play with contrasting sizes of mark and shapes of pure colour. See what happens when you experiment with unusual combinations. Do not deliberate for too long and keep your colours clean and fresh; spontaneity should lead you forward.

Abstraction is primarily a twentieth-century development that has moved beyond the restrictions of known and seen reality. Artists began to believe in the intrinsic values held by shapes, colours and forms and celebrated them as art in their own right and not just the composite parts of a recognized whole. Of course, this shift of emphasis was rooted in the natural world, but totally separate from it, and both Franz Marc (1880–1916) and August Macke (1887–1914), two leading exponents of the German 'Blue Rider' group, expressed their profound vision of human spirituality through the dynamic, fragmented forms of wild animals.

For many artists, abstraction is the final destination of a lifetime's visual journey that begins with a formal training in representational art. The basic elements of pattern, colour, line, tone and surface texture are taken and reconstructed pictorially to appeal to the viewers' senses. There are different expressions of abstraction, but all weigh-up certain tensions found in the elements of composition. Pictorial balance, imbalance, and dynamic movement are all key to the successful completion of an abstract painting, and upon such structural, compositional frameworks hang the content, defined as theme and chosen painting techniques.

One approach to the abstracted image is through gestural and vigorous mark-making, layering mutable hues to create a 'sensational' surface texture. Another is harder-edged and carefully considered, through logical process or geometric construction, coupled with an orderly, regulated palette. An excellent example of proficiency in both is found in the work of Paul Klee.

Creating an abstract

Select a group of forms, perhaps a strongly shaped object like a tree or part of a building, or maybe even a shadow thrown across the ground. From these, decide which shapes have the strongest visual significance. Next, choose a harmonious or contrasting colour range, no more than six colours, and design the shapes, or part shapes, into a composition – moving their positions, and altering their scale, until they have created an eye-catching and dynamic arrangement.

TIP

Try not to allow the temptation of copying reality get the better of you. Keep your shapes and colours simple.

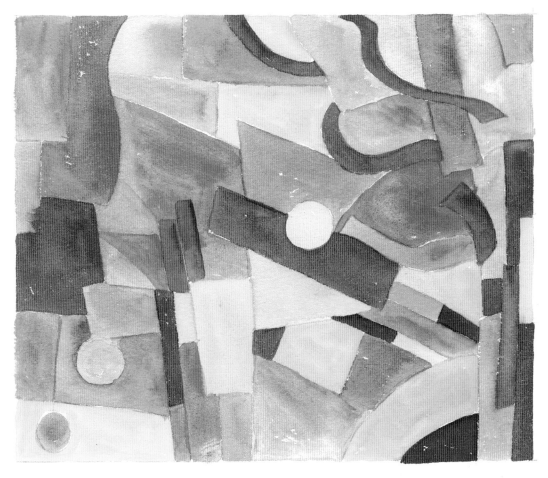

The blue arch with orange centre, was as pleasing to undertake as it is to look at. Influenced by the American artist Georgia O'Keefe, its simplicity and use of complementary hues gives it endearing qualities.

The geometric approach adopted by Klee and Kandinsky provided the formula for this lively abstract. The starting point was a tree on the left hand-side of the picture, but in the excitement of picture-making, I broke its trunk and branches down into vertical shapes and snaking bands, which in turn overlapped other landscape forms. The final result, although not entirely coherent, has a rhythm and structure that is concordant and pleasing to the eye.

Creating an abstract

Celebrating the power of shape and colour through the soft luminous hues of his palette, John Sell Cotman scaled the heights of his painting career, at the very young age of 23. His nineteenth-century watercolours, made on his travels across evocative landscapes, reveal a fine sense of structure and pattern which must have been extraordinarily modern in its day. The well-known painting of 'Chirk Aqueduct' has been chosen as a suitable example to copy and then reconstruct as an abstract image of strong, geometric, simplified shapes.

Copying the Cotman

The purpose of the exercise is twofold.

1 To gain an understanding and appreciation of the working methods and colour palette of Cotman.

2 To practise and develop an appreciation of the principles of abstraction, using a familiar figurative image as its base.

The watercolour is fairly limited in palette, the lightness of the washes being responsible for its sense of morning luminosity. After faintly pencilling the composition onto a piece of stretched, NOT paper, a pale cobalt wash was laid onto the top section of sky and this is mirrored in the still, reflected waters echoing beneath.

A pale ochre wash, slightly drier than that of the sky, covers the solid columns and arches of the viaduct, and broken colour allows the whiteness of paper to show through. The interior recesses of the arches, cast in shadow, were mixed out of the cobalt blue of the sky, yellow ochre and burnt umber. The darker stains, representing river bank and foliage, are very earthy with a predominance of burnt umber brown. The background tree forms have a hint of green showing, and I mixed a smidgen of emerald green into the recipe.

Cotman chose to leave his whites shining through virgin paper, rather than follow the popular whitening process of the day, the addition of body colour. It is small, detailed fencing and bare tree branches for which he used this technique.

The sandy bank directly in front of the central arch has the same yellow ochre hue with a hint of umber added. This has created a clever base-shape which leads the eye into the reflected columns in the still water below.

The water has been warmed with the barest hint of both cadmium red and a purple madder. Again, a broken effect was encouraged to produce reflected light on the water surface.

Final details like foreground pebbles and leaf strokes were very subtley added with a smaller brush at the very end.

TIP

Copying is not just the finest form of flattery. It also serves as a valuable aid to your learning. There is no finer way to learn about watercolour painting – its appreciation and practice – than through the copying of Masters.

Abstracting the Cotman

Because the shapes are so prominent they were easy to divide in the first instance, by simply tracing them from my Cotman copy with tracing paper.

Next, I reorganized the shapes onto my fresh sheet of watercolour paper – NOT surface – letting the strength of the arch shapes dictate the free organisation of other elements. I took liberty with scale, further abstracted the shapes and had a lot of fun reassembling the original into a new, constructed image.

The colouring of the work I could have taken through an infinite number of palette options. In the end I left myself the dilemma of just two. Should I use the colours of the original or totally change them? For the sake of a totally new creation, I threw my energies into the latter and used strong vibrant colours, being clearly influenced by the European moderns, especially Wassily Kandinsky and Paul Klee.

1

The copy of Cotman's Chirk aqueduct reveals strong composition and excellent tonal balance. Both properties are vital to the abstraction process.

2 | *A traced outline* simplifies the composition into linear shapes.

3 | *The shapes are reorganized* and simply redrawn onto another overlay tracing sheet.

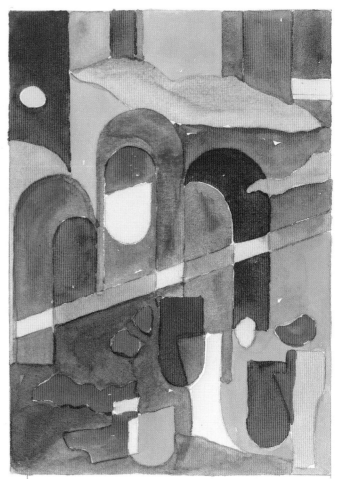

4 | *Colours are selected* and painted into the shapes.

Developing your language

To dabble in watercolour is to express ideas through the language of paint marks and washes. It is the painter's poetic medium, possessing the versatility to communicate a soft whisper in a wash, or a hollering cry in a vibrant paint stroke. Under your guidance it can awaken beautiful sounds, flow with attractive rhythms, and be constructed by way of its many disciplines, into fluid narratives and musings of the imagination. Its special qualities even extend into the realm of rapid note-making, a sort of shorthand sketching, where its speedy drying and portability make it the excellent locational tool.

However you choose to use the medium – and by now you should be well versed in the techniques – your fluency should automatically begin to reveal a personal, handwritten style; the unique way that each practitioner handles the same raw material has to be one of its most inspiring and exciting attributes. You should nurture a working knowledge of other watercolourists, past and present, and learn from their study and practice of the craft. Always be selective, it might just be one particular aspect of an artist's handling of paint that has a strong influence on your own work. Looking at others' work and learning by imitation is essential if you are to develop your own style. I remember being very bothered about style while at art school, noticing how others around me had nurtured, from very early on, a definite stamp, unique and recognizable in all that they produced. My progression passed slowly and unnoticed for many years, but has emerged after much contemplation and application, with an equally strong stamp.

TIP

To avoid becoming a 'style factory' with overly exploited techniques that make your pictures look mannered, consider the intention of each piece before you begin. Choose the main elements and then decide from your repertoire how best to describe each. Enjoy the unique way that you handle paint and never compare yourself to others negatively.

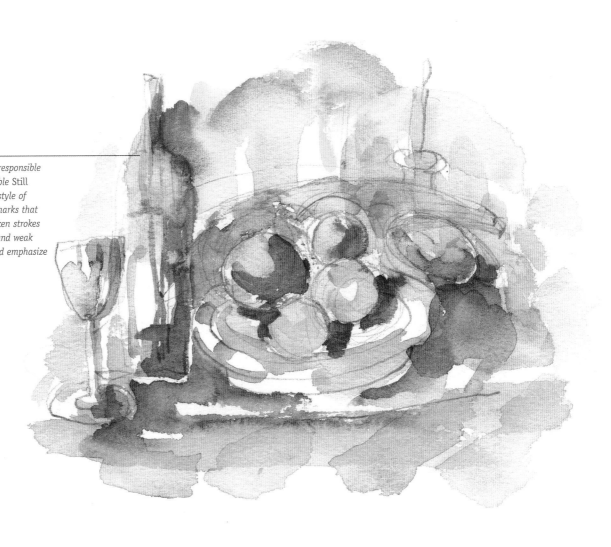

Paul Cezanne

Light and colour were principally responsible for defining the forms in his notable Still Lifes. *This picture, worked in the style of Cezanne, includes sketchy pencil marks that have been built up with thin, broken strokes of complementary colour. Strong and weak washes butt up to one another and emphasize reflected light.*

Cobalt blue

Cadmium Yellow

Cadmium red

Emerald grreen

Violet

Burnt umber

Indian red *Brilliant green*

Alizarin crimson *Cadmium orange*

Cerulean blue *Cadmium red*

Emerald green *Cadmium yellow*

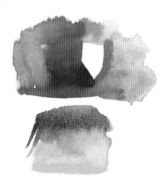

Emil Nolde

Forceful tensions can be expressed through rich, dark shades of pure colour. Nolde, the twentieth-century German expressionist, was a master manipulator of saturated colour, inviting his viewers to share in his raw emotions.

Emerald green

Violet

Cobalt blue

Yellow ochre

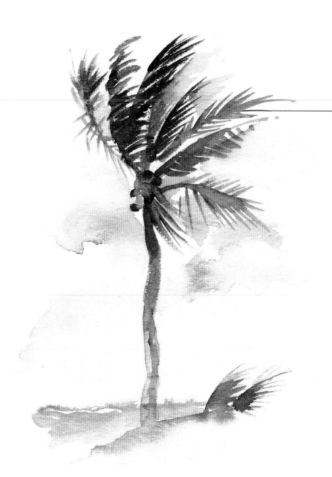

Winslow Homer

Homer had the innate ability to express the sentiment of his native America, through his exploitation of traditional techniques with a limited palette. His sensitive handling of subject matter marks him out as one of the great modern masters of watercolour. By copying a palm tree blown by the full force of the gale, greater insight was gained into his use of wet-in-wet, wet-on-dry, and dry-brush strokes. They exemplify the unity that exists through technique, and do so without looking too slick or formulaic.

Emerald green

Lemon yellow

Violet

Brilliant green

Cadmium

Cerulean blue

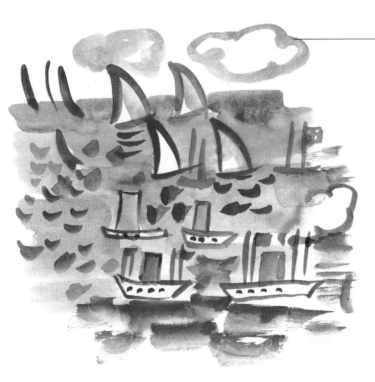

Camille Pissarro

Impressionism has always been less explored in watercolour than in the saturated vibrancy of oil. Dabs of strong colour merge in liquid pools of complementary hues, and light reflects through the whiteness of paper, creating the sensation of sunlight upon objects. These trees have followed this approach in the style of Camille Pissarro.

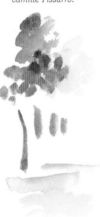

Cobalt blue

Cadmium yellow

Ultramarine blue

Cadmium orange

Violet

Cadmium red

Raoul Dufy

This boat study after Dufy features rapid, assured strokes that fluently touch smooth paper in a deceptively simple way. Complex subjects are simplified into coloured shapes, swept with colourful, watery washes.

Working on location

It takes courage to sit before your subject in all manner of weathers, and respond to it with carefully chosen colours and suitable strokes. Knowing how to equip yourself appropriately for these different situations can take the strain out of painting, and allow you to concentrate more fully on the task in hand.

TIP

If you are out visually recording and have neither time nor the inclination to complete a full colour piece, make colour notes against your sketches and fill them in later. This paint by numbers approach is extensively practised by watercolour painters.

Whether you are working on a building site or public footpath, always adhere to warnings or requests, and in the case of private property, seek permission first. Be courteous to fellow users and never put yourself or others in any danger. If you are sketching or painting in a public place, try to find a location that is neatly tucked out of prominent view, especially where your subject matter includes the direct study of people. Staring at someone for long periods is an invasion of that person's privacy, and should be avoided. Learn to look and memorize what you see in shorter bursts, so that your activities are less conspicuous.

Take short, regular breaks: every 40 minutes is good as the brain fails to fully concentrate after this time. This will give you a natural rest and the space that you need to refresh your thinking, and objectively assess the work in front of you.

Finally, a basic first aid kit is helpful to tuck away in case of unforeseen emergencies.

Always wear suitable footwear, *appropriate to the terrain that you are visiting. It can be extremely dangerous, for example, when climbing to the painting location, not to be wearing special walking/climbing boots.*

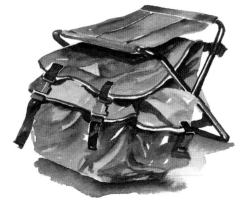

What you choose to keep your possessions and materials in is your own personal choice. A good, lightweight waterproof satchel or rucksack with small, separate compartments is excellent and, as mentioned at the beginning of this book, some sketching stools support an integral bag. Resist the temptation to take anything too large. Such items are all too easy to fill!

When choosing painting equipment, take only what you know, or think you know, that you will use. Your small sketching watercolour box, a couple of pencils, pens, soft eraser, water bottle and pot, small sketchbook and, where applicable, sheets of watercolour paper. Keep them attached – or, in the case of one sheet, stretched – to a lightweight board, and carry clips and a roll of masking tape to affix them. You can buy a special roll-out canvas bag, with sewn slots, to keep brushes in, or, like me, keep them together in a narrow cardboard tube with press-on ends. It is important that in storage you do not allow their 'heads of hair' to become misshapen.

TIP

If you find yourself without paints, but need to make marks, improvise with what is at hand. Many a café sketch has been painted with tea, coffee, or hot chocolate.

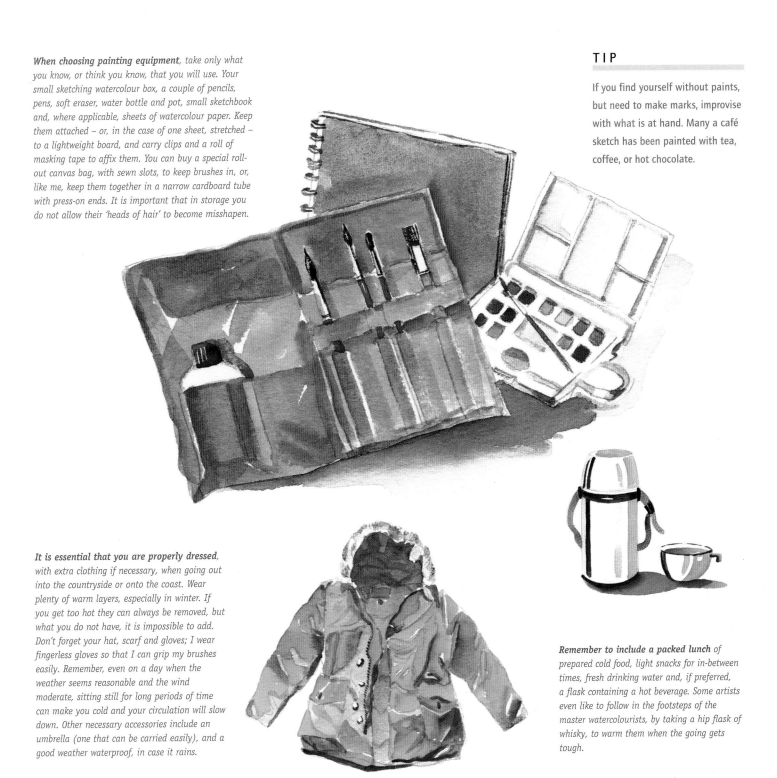

It is essential that you are properly dressed, with extra clothing if necessary, when going out into the countryside or onto the coast. Wear plenty of warm layers, especially in winter. If you get too hot they can always be removed, but what you do not have, it is impossible to add. Don't forget your hat, scarf and gloves; I wear fingerless gloves so that I can grip my brushes easily. Remember, even on a day when the weather seems reasonable and the wind moderate, sitting still for long periods of time can make you cold and your circulation will slow down. Other necessary accessories include an umbrella (one that can be carried easily), and a good weather waterproof, in case it rains.

Remember to include a packed lunch of prepared cold food, light snacks for in-between times, fresh drinking water and, if preferred, a flask containing a hot beverage. Some artists even like to follow in the footsteps of the master watercolourists, by taking a hip flask of whisky, to warm them when the going gets tough.

The approaching storm is noted with fluid, heavy strokes in the sky and wet-in-wet for the main tree.

It starts to rain and the wet pigment starts to break up and be carried by spots of rain.

As the deluge takes hold, edges are blurred into wetness but certain details are still distinguishable.

Painting in the rain and snow

In this view to the sea, the weather was bright but misty, with a fine drizzle falling throughout the duration of the painting – about 15 minutes. Note the spotty impression left on the paper even after it has dried.

Working with nature

If, like me, you come from a country where rainy days are common, then why not capitalize on the precipitous proliferation and include it as part of your watercolour-painting programme? Some places have regular seasons of rain or snow in their calendar, and these can be scheduled at leisure into the diary. A little-known English watercolourist of the mid-twentieth century, Tom Hennell, made the most extraordinary sketchbook study during the bitter winter of 1941. As he expressed the raw, exposed farmland, his washes froze into crystalline ice patterns, which remain to this day!

Whenever I take students out to sketch in the rain there is often consternation and bleatings of anxiety or disbelief at the proposed task! But provided you have an umbrella, warm, waterproof clothing and a place at hand to which you can quickly take refuge, then painting in the rain is the most exciting way to allow nature to effortlessly assist the laying of washes.

Working tips

- Pre-stretched paper, affixed to a wooden board with brown, adhesive, gum-strip tape, will allow images to be painted in the rain with no cockling occurring.
- Sketchbook pages will buckle and warp, but it does add to the authenticity of the work – an honest approach to recording the moment.
- Remember not to close the pages of the book until it is totally dry.

Exercise

It may be that you get caught in a shower or the beginning of fine drizzle. If this happens do not panic, just let the sharp edges begin to dissolve into wet, mottled stains. In their splattery distortion, the marks should hold enough information to still be deciphered. Let this be your guide to knowing when it is time to stop and swiftly leave. If you do not make a definite decision, you stand the risk of losing all your hard efforts.

Painting with the intention of using the rain is like applying wet-in-wet on tap! The rain-soaked sheet will have already provided the base into which pigment can be dropped. The level of control is totally dependent upon the strength of the rain, and unlike wet-in-wet, where the brush alone spreads the colour, under these circumstances the raindrops are also contributing to the spread and dilution of the paint.

The figure with the umbrella was drawn directly with a brush as rain got progressively heavier. The washout effect leaves little detail, but enough to strike the essence of the pose.

Planning order of work

Spontaneity is marvellous, but the painting that works best at every level as a result of the spontaneous is a rarity. Advance planning and the formation of set tasks gives picture-making the room it needs to develop. Most paintings need to be carefully mapped out through a number of set processes, all the while refining the stages to bring about a stronger end product. There is no definitive way to plan your work, but a sense of order and structure are necessary to help you to realize your objectives.

I took some sketches made in a fruit market and used them to plan a lively narrative scene which still held the spirit of the original sketches in its final draft. I did not take this 'rough sketch' to the next stage of final painting, because I felt that I would not have retained the hustle and bustle that had inspired the original sketchbook drawings.

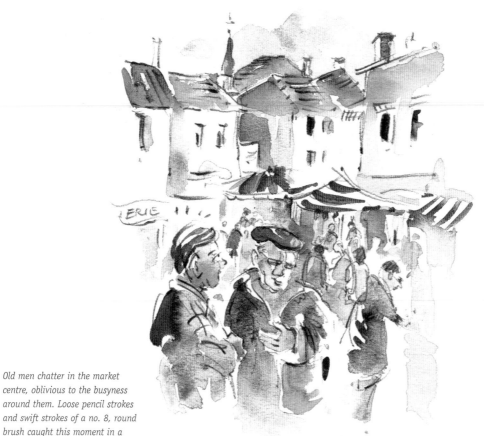

Old men chatter in the market centre, oblivious to the busyness around them. Loose pencil strokes and swift strokes of a no. 8, round brush caught this moment in a matter of minutes.

Sketching and taking photographs

Recorded observation is essential. The combination of sketchbook and camera is great for recording moving events or for when you are travelling around. A photographic or digital snapshot can be an invaluable aid where you do not have enough time to get it down on paper. The marks you make in your book will capture the energy of a situation as it unfolds before your eyes, where the camera may present a more static viewpoint.

Treat your sketchbooks as seedbeds of ideas and a place for practical mark-making and exploration. Page spreads can assist your flow of creative ideas and bring them to fruition.

Reference photographs can help you to attain greater accuracy in your work, especially where figures are concerned. But do not take too much notice of superficial, photographic colours.

Rough sketch

Using pencil or pen, redraw your decided composition with a greater level of detail, planning the position of the elements according to your thumbnail sketches. Be careful to lay your washes with lightness, and keep pencil or pen marks sketchy, with the immediacy of the original drawings.

The shapes of the succulent fruits first caught my eye and I rapidly sketched them down with an HB pencil. Stallholders make excellent subjects because of their repeated movements, allowing you the time to record their actions. These were added behind the fruit crates.

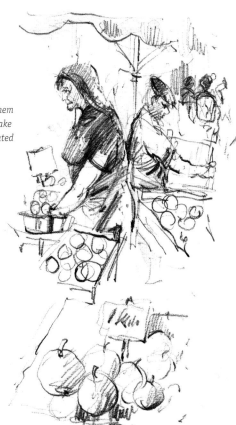

The sequence of a bending lady attracted me in its simplicity. By overlapping her progression using a single pencil line with selected washes of green and brown, I was able to capture the essence of her character and movement.

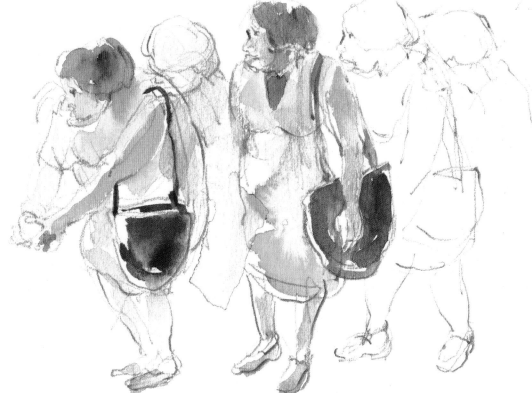

Thumbnail sketches and decision-making

Once you have decided on a theme, consider which elements you might like to include from your various reference sources. Draw up smaller images and loosely indicate the size and placement of objects in the rectangular space. Be adventurous – try cropping some items beyond the edges of the paper and consider how certain objects might be transformed into 'devices', strategically placed, for leading the eye into and around a picture. Keep making thumbnails until you are happy with the design.

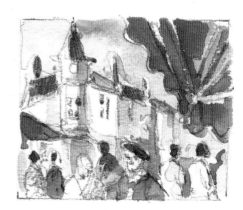

These thumbnail sketches were executed as small, rectangular studies in HB pencil, with added splashy washes indicating the tonal emphasis for the rough sketch that was to follow.

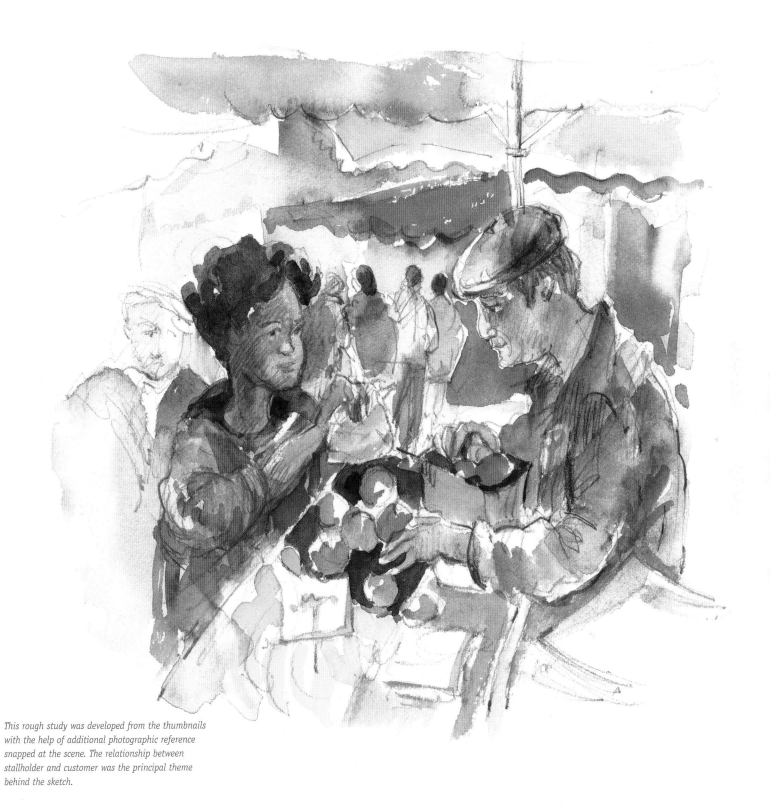

This rough study was developed from the thumbnails with the help of additional photographic reference snapped at the scene. The relationship between stallholder and customer was the principal theme behind the sketch.

Masterclasses

Landscape

Tuscan Hills

Efficient, portable, spontaneous, fast-drying – these are all qualities which make watercolour the key medium for capturing nature's constant changes. How we respond to the breathtaking stimulus provided by topographical subjects is greatly dependent on seasonal changes, weather and light. The physical appearance of the landscape is determined by the combination of these factors, and brings enormous fulfilment to anyone wishing to study it visually.

Yellow ochre

Burnt sienna

Cadmium red

Ultramarine blue

Violet

Emerald green

Brilliant green

HB pencil

The lightness and translucency of skies, as they absorb and reflect the brilliance of the sun, can be translated with ease into washes of pure and mixed colour, vibrant and subtle, interpreted through an extraordinary range of hues and quality of mark that so closely match the real thing. The diversity of the medium also allows for the creation of harder structures, such as rocks, trees and rural buildings, by painting with denser saturations and harder-edged brushwork.

In this landscape masterclass, I recreated a late afternoon scene in the heart of Italy's Tuscany region. The prominence of rolling, wooded hills set against a dramatic, looming sky set up complex

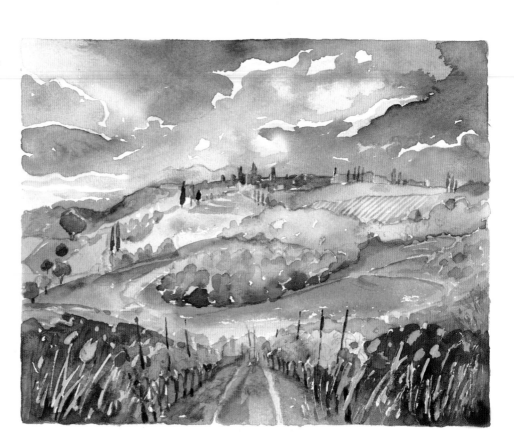

problems which were best resolved through the practice of 'aerial perspective' – the perception of space created by varying tones. Warm, dominant strokes of red and burnt sienna were played against the cooler, simplified washes of Prussian blue and emerald green, which established the illusion of depth. The village silhouetted on the horizon was reduced to basic shapes and the sky displayed the familiar effects of 'Contre Jour', literally 'painting against the day', a phenomenon that occurs when the sun is low in the sky, causing halo effects around the edges of clouds and other solid objects as it passes behind them.

Initial pencil sketch | 1

Loosely and lightly, the main shapes of the landscape were outlined onto stretched 140lb (300gsm) NOT surface watercolour paper, recognizing the foreground with vines and flowers, middleground trees and background hills and villages.

TIP

Think carefully at every stage, and plan your next move, with thumbnail sketches and working drawings where necessary.

Masking out | 2

Texture and colour display interest in the foreground of my landscape so, with a nib pen, I masked out flower heads, stems and grass by drawing them in masking fluid solution. This I let dry completely before moving on.

Painting the sky | 3

Using ultramarine blue, violet and yellow ochre with a no. 8 sable round brush, I painted an early evening sky, allowing the bare, white paper to create the halo around the cloud shapes. This requires a certain amount of forward planning, and I could not leave my placing of these whites to chance. As the colours mixed and spread into the shapes in between, the wet-in-wet technique described their vaporous nature, and soft edges defined the overlapping shapes.

4 | **Working the horizon**

The next decision taken was the laying of background tones where sky meets land. Unusually, because of the low light, the village and receding hills are partially silhouetted and the tones were painted much darker than they would be, under the rules of aerial perspective, although they are still cool, having been mixed from the colours of the sky with added emerald green.

Beginning the foreground | 5

The distinctive Tuscan earth, represented in the composition by burnt sienna, was dropped into the middle band of the picture using a no. 10 sable round brush, which helped to draw the eye towards the foreground. Tree clumps were simplified into soft, wet, rounded shapes of emerald green with a hint of ultramarine blue and violet in the shadowy regions.

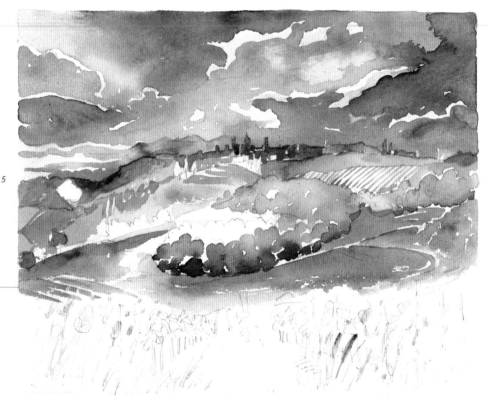

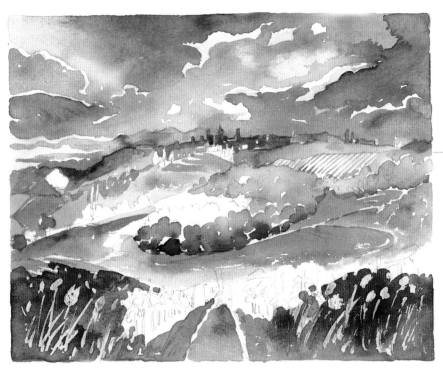

6 | *Building up tone*
Strong washes of yellow ochre, cadmium red and burnt sienna were dropped into the foreground over the masked-out areas with a medium wash brush.
The warmth and depth of the foreground colours clearly separate foreground from the middle and background picture planes.

Finishing touches | **7**
White areas of tree clumps and fields were next to be defined, and the vines dropping downhill into the valley were brushed in with the fluid strokes of a fairly large sable brush, no. 8, using brilliant green and yellow ochre. With the picture now having reached its final stage, finer details were checked with a no. 4 round sable brush. The temptation to overstate parts of the picture was resisted, and the painting retained its slightly impressionistic character.

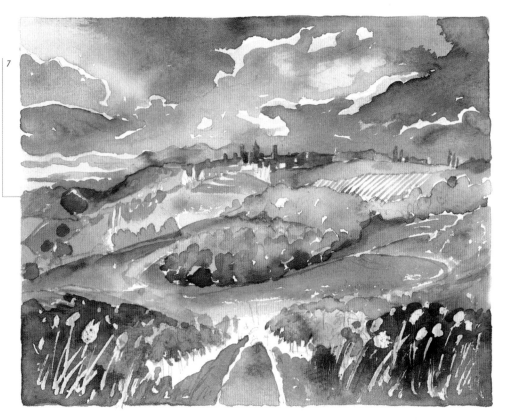

Techniques used

Wash (*page 34*)
Wet-in-wet (*page 37*)
Wet-on-dry (*page 36*)
Sketching (*page 104*)
Soft edge (*page 38*)
Variegated wash (*page 35*)
Masking (*page 56*)
Reserving (*page 40*)

Portrait

Caitlin in Summer

Engaging the human figure in drawing and painting is perhaps one of the hardest tasks. You need a model or reference from which to work and the aim is to capture something of their personality. The easiest way to find a sitter is to look at yourself in the mirror. Self-portraits often look intense, revealing the artist's concentration as they try to assemble the features into a recognizable image. Or select a friend, who will not be negatively critical of your best efforts.

Yellow ochre

Cadmium orange

Cadmium red

Cobalt blue

Prussian blue

Emerald green

Violet

Alizarin crimson

HB pencil

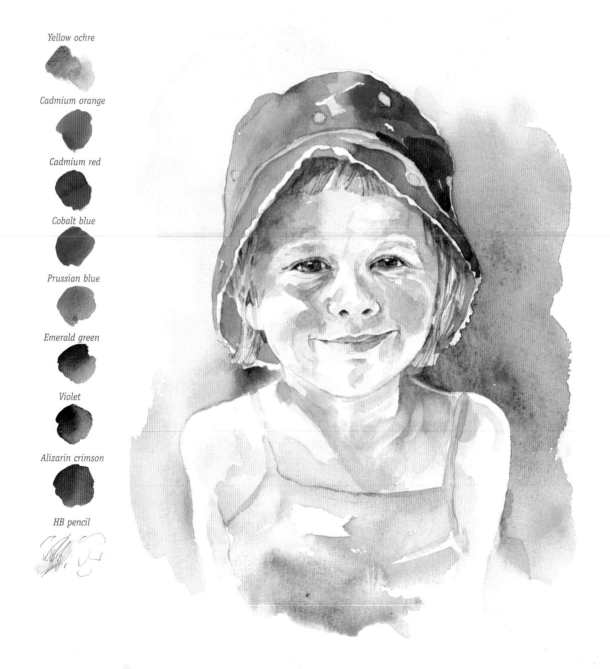

Learning to paint the human figure with great accuracy is not something that can be mastered in a few attempts, it could take years, but the fulfilment and enjoyment will more than outweigh the hard struggle getting there. Attending portrait and life classes are worth doing if you have the time, as they will assist your learning of anatomy and structure and give you an excellent grounding upon which to apply the techniques and approaches detailed in this project.

Getting a likeness is important when drawing a portrait. Every face does tell a story. Stresses and lifestyle can show through the wrinkles and furrows in a person's appearance, and these are not necessarily a bad thing. They reveal character and make the task of portraiture far more interesting. This is why the elderly are so good to draw, with a lifetime of experiences expressed in one unique part of the body. The young on the other hand are very difficult, and require careful editing of features and subtlety of paint strokes to define their charm and innocence.

TIP

When drawing portraits, do not let the background detract from the main image, by being too strong in colour or too detailed. Keep backgrounds simple and nondescript.

1 | *Initial pencil sketch*
You may choose to use photographic reference to assist your portrait. Tracing the main elements is fine and you should get accurate proportions, but under no circumstance attempt to imitate photographic colours, as they can leave a painting, in particular a watercolour, looking flat, stilted and lifeless. On a stretched A3 sheet of NOT or hot-pressed watercolour paper, the basic positions of eyes, nose and mouth were lightly established and the main areas for laying foundational, tonal washes were indicated with feint, linear HB pencil lines.

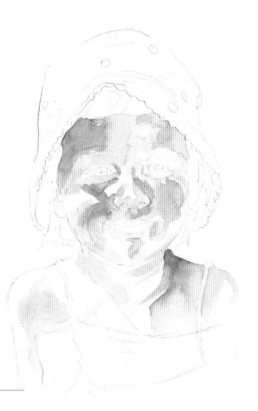

***Adding skin tones* | 2**
Skin tones are not just squeezed from the tube as 'flesh tint'. It is most realistic to mix your own from three colours. I used cadmium red, yellow ochre and cobalt blue to produce the delicate tints for Caitlin's face and, with a no. 6 sable round brush, flowed the tones into place replenishing and mixing as I went. For the more shadowy areas under the hat and around the eyes, I kept the washes denser, only diluting them for high-lit areas. Pure white was left as bare, white paper.

*Preferring to establish a full range of tones, I painted
the eyes with a blend of cobalt blue and emerald green
using a no. 4 round sable bush. Where the light catches
the centre of the pupil, I again reserved the white of the
paper, for optimum sparkle. The deeper shades around
the eye sockets were increased with a dilute mix of
cadmium red and cobalt blue.*

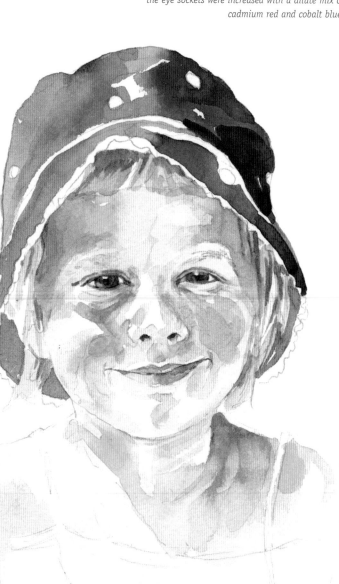

4 | **Strengthening the detail**

*The hat is an important part of this picture because it neatly
frames the head, providing a strong window through which to
gaze upon the softly featured face.*

*A larger, no. 10 round, sable brush was used to flood the area
with strong passages of Prussian blue, which were lightened by
dilution towards the left hand side of the hat – the area receiving
the light source. The mouth was painted in with a little added
blue. Colour was applied in translucent layers so that they did not
become heavy in appearance, and the hair was laid down as wide
strokes of yellow ochre, cadmium red and cobalt blue. To
emphasize hair shapes and facial contours the lining of the hat
was painted in alizarin crimson.*

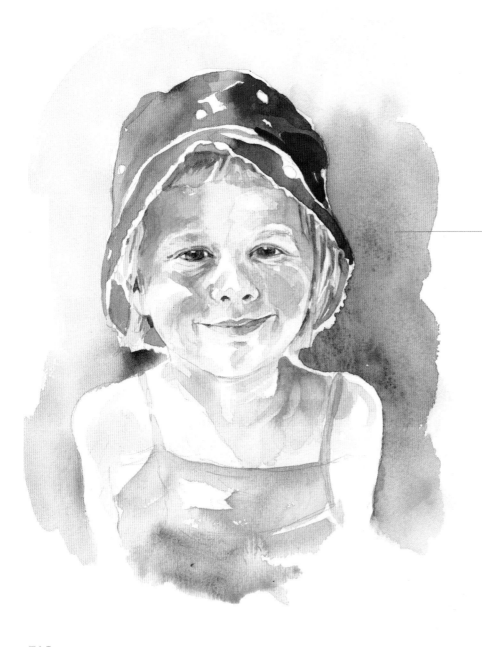

5 | Adding depth

The vest was painted next, which extended the depth of the portrait to a visually comfortable distance, that of the chest. Lively, gestural brushmarks were dragged over the area in cadmium orange and a hint of brilliant green, and allowed to bleed naturally along the bottom edge. More detail was then delivered to the main part of the face with a smaller no.2 round brush; brow-line in yellow ochre, strengthened laughter creases around the mouth and the remaining hat lining in alizarin crimson. To help push the model forward in the composition, broad, fluid washes of emerald green and violet were flooded wet-in-wet, around the outside contour of the figure.

Finishing touches

At this stage, I stepped back from the work and reassessed the values. More cobalt blue and cadmium red was dropped either side of the face where the brim casts its shadow. The setting of the eyes was further deepened with blue and red combined, the nostrils darkened and more detail was built up in the hair and on the shoulders near the top of the neck. Some of the earlier pencil marks had made unnecessary hard lines under the soft, facial washes and I decided to remove them from the dry paper with a very soft, plastic eraser. This must always be done with ultimate care, and only when your colours are totally dry. The last stage was devoted to adding fine details with a no.2 brush, brought to a point. Eyelashes were added, the occasional strand of hair picked out with a violet and cadmium red mixture. Detailing was selective and restrained, as there is always the possibility of over-killing the freshness with excessive strokes.

TIP

To be made aware of facial structure does not require large volumes on anatomy. Why not explore your own skull, feeling the flatness of your temples, pronounced cheekbones and hollows of the eye sockets? All the while, try to visualize the different shapes and surface planes that you are feeling – check the shape of nose and chin, or the softness of the lips before eventually arriving back up at the temples. This little exercise will help you to understand better what lies under the skin, and you should recall your thoughts when you are struggling to apply washes that describe what lies beneath the skin.

Techniques used

Dry-brush (*page 48*)
Hard and soft edges (*page 38*)
Reserving (*page 40*)
Sketching (*page 104*)
Wash (*page 34*)
Wet-on-dry (*page 36*)

Painting a building

Royal Pavilion

Painters of portraits get below the surface of their sitter to reveal something of their character through a suitable likeness, using sympathetic painting techniques. Success is measured by the viewers' response to the image of someone they feel they know well, painted in such a way as to somehow bring that person to life. The same is true of buildings and places that we have become fond of. However, so often the accurate rendering of architectural principles overrides the desire to capture the charm of beautiful structures, and the result is soulless and stilted. In this project, I have painted the fanciful portrait of a familiar friend.

Crimson

Violet

Ultramarine blue

Cadmium yellow

Cadmium orange

Viridian green

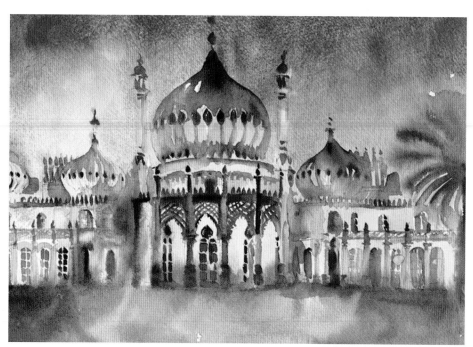

The orientally inspired Royal Pavilion in the English coastal resort of Brighton is a flamboyant charmer. Gloriously floodlit by night, its minarets and domes glow with a muted, yellow luminosity, to great atmospheric effect. This prompted me to make a visual record with the help of a photograph taken on a previous evening visit. This proved to be unsatisfactory, and I felt that by using the lustrous palette and variety of techniques offered by watercolour, I could capture the imposing sense of grandeur in a more evocative way.

From a light pencil sketch outlining basic shapes and surface decoration, I kept detail to a minimum, choosing instead to draw out the exaggerated features of the building, which create their own caricature. The spontaneity of wet-in-wet techniques made a good base, and allowed the soft diffusion of light to be represented as the fluid hues mixed. Colours were limited throughout, with warmer crimson, violet and ultramarine for shadows, and cadmium yellow and orange for lighter areas, contrasting against viridian green which separated the spreading palm from the merging mass of buildings.

TIP

The angle at which your paper is tilted will significantly determine the end result. Wet paint will always run downwards when the board or pad is lifted, which is excellent where directional movement is desired.

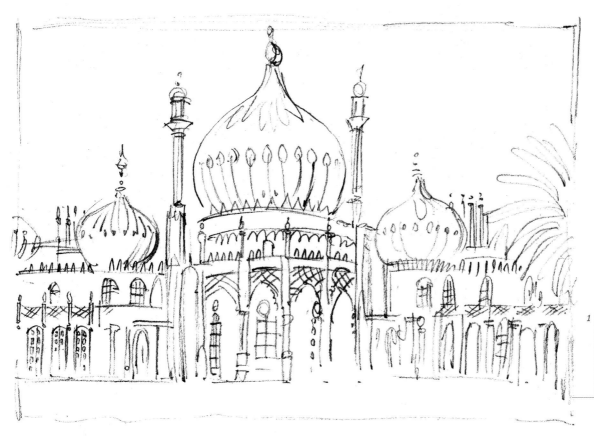

1 | *Initial pencil sketch*
An initial sketch outlining the main shapes in composition, was made.

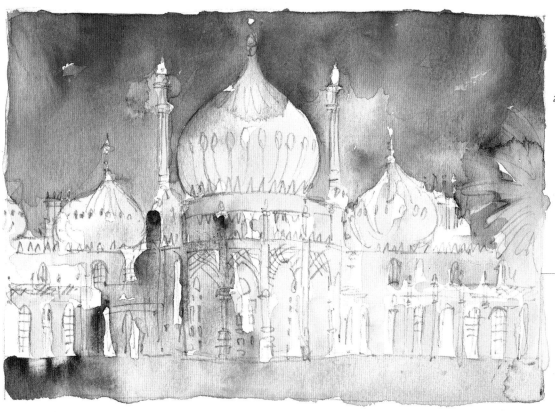

2 | **Hard edge over wet-in-wet**
The minarets are painted by first laying down variegated wet-in-wet washes, moving around and across the surface of the dome from light to dark to convey the illusion of three-dimensional form. When these washes have dried, further detail is added as another layer of wet-on-dry brushwork. The building is a highly detailed, fancy structure, but for the purposes of the study only main features need to be selected and painted, using a no.4 round sable brush.

Techniques used

Graded wash (*page 34*)
Hard and soft edges (*page 38*)
Reserving (*page 40*)
Sketching (*page 104*)
Variegated wash (*page 35*)
Wet-in-wet (*page 37*)
Wet-on-dry (*page 36*)

4 | **Painting the sky**
The sky is given a traditional wash using a fully loaded flat wash brush on fully saturated paper. This causes the pigment to bleed and disperse outwards.

5 | **Wet-in-wet, light colours**
The main shapes of the building are directly brushed in, applying the lightest colours first. The paper is still flooded and the yellow bleeds into the blue sky to give the illusion of pools of light.

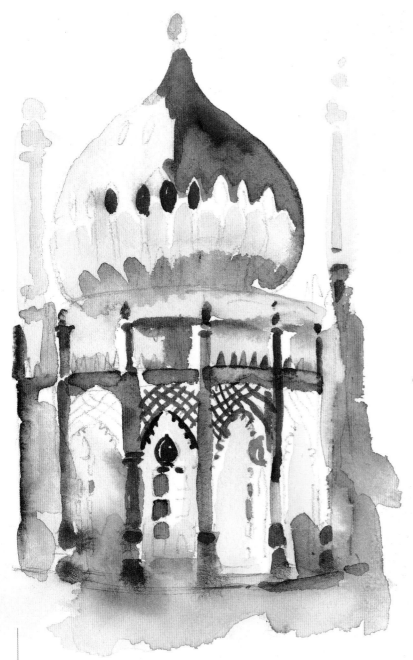

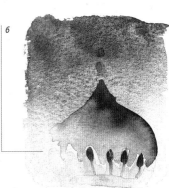

Wet-in-wet, dark colours | 6

As the paper begins to dry off, the darker shadow tones are added to build form into the Pavilion. There is still bleed in certain areas creating random effects, which are part of the character of the medium.

Wet-in-wet | 7

Cadmium yellow and cadmium orange are applied wet-in-wet and allowed to merge naturally, forming backruns where they will. Violet and ultramarine are quickly brushed in wet-in-wet for the shadows.

Wet-on-dry/hard edge | 8

To retain the spontaneity of the painting, detail is included only where it helps to build form and give definition. Added at the very end, the wet pigment creates a hard edge where it is overlaid on the dry layer underneath.

3 | **Rendering the pencil sketch**

This intermediate stage shows how the fluid washes are dropped into place over the light, pencil sketch. A tonal range is considered, and to give the palace a sense of structure and three-dimensional form, light, middle and darker tones are loosely brushed in. The brush sizes are large – sizes 6, 8, and 10 round sables and a couple of flat brushes are all used to keep the paint moving without unnecessary hard-edge lines and backruns.

Animal portrait

Kitten at Play

All living creatures share common attributes. Their frame is a skeleton of interlocking bones, jointed to allow movement in particular and peculiar ways, but it also serves as a protective cage, holding vital organs in place to keep the animal alive and functioning efficiently. Muscles and arteries work this amazing bodily machine, pumping blood to keep vital organs working, and over the top of all this, each animal has its own uniquely coloured and textured skin, which helps to define it to its own and other species.

Cadmium red

Yellow ochre

Watersoluble pencil

Burnt umber

Watersoluble pencil

Sepia tint

HB pencil

Violet

Cats and dogs make wonderful models, where in their domesticated bliss, they will pose in many intriguing positions – often very relaxed or even asleep! For other animals visit pet stores and zoos, and use a convenient size of sketchbook to record the vital shapes and movements of the creatures that you see. Try to visualize animals in much the same way as you would a human being, namely as a complex living object comprising a number of three-dimensional, interlocking shapes. Try to draw around the whole figure, ultimately viewing it as one bodily mass. But do not hold too high an expectation for yourself. Remember that conditions on location are less than perfect and it is very unlikely that your models will keep as still as your pets indoors.

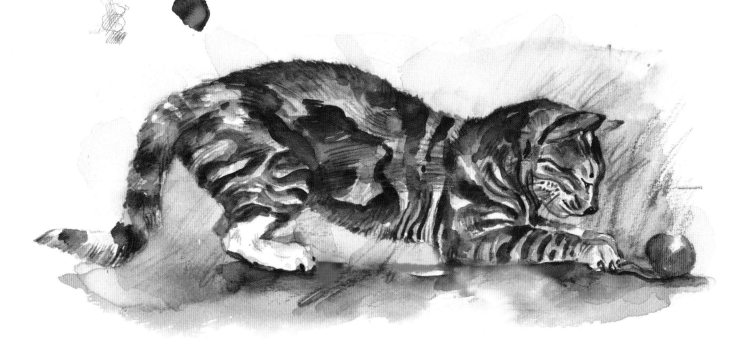

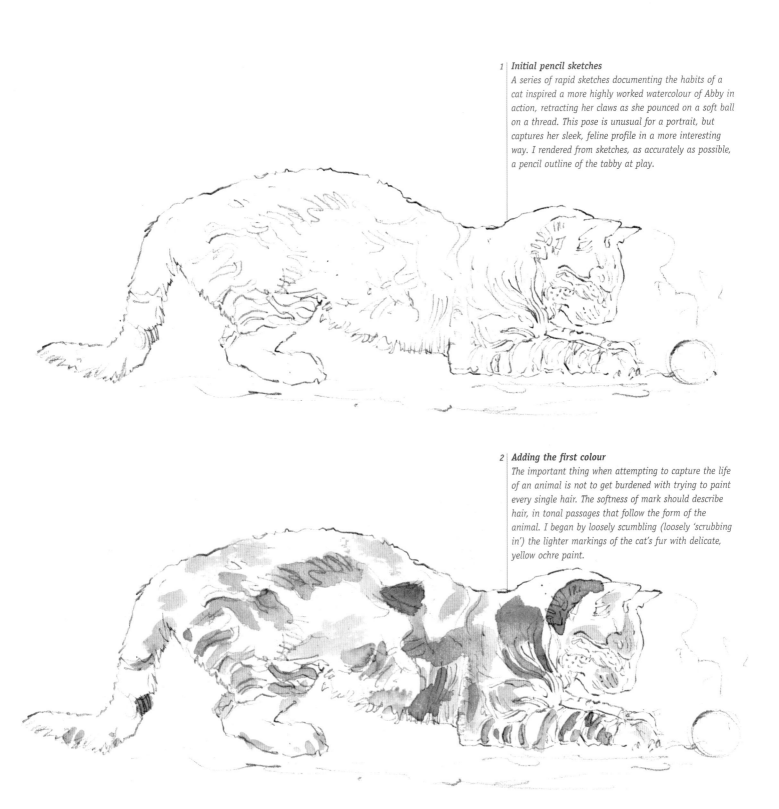

1 | Initial pencil sketches

A series of rapid sketches documenting the habits of a cat inspired a more highly worked watercolour of Abby in action, retracting her claws as she pounced on a soft ball on a thread. This pose is unusual for a portrait, but captures her sleek, feline profile in a more interesting way. I rendered from sketches, as accurately as possible, a pencil outline of the tabby at play.

2 | Adding the first colour

The important thing when attempting to capture the life of an animal is not to get burdened with trying to paint every single hair. The softness of mark should describe hair, in tonal passages that follow the form of the animal. I began by loosely scumbling (loosely 'scrubbing in') the lighter markings of the cat's fur with delicate, yellow ochre paint.

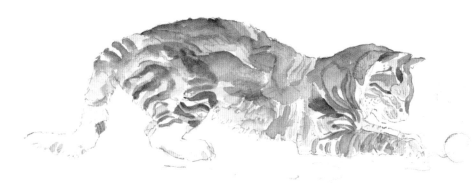

3 | **Considering form**
Tone describes form. Patterns can also help especially where the tabby's markings follow the muscular joins of the limbs and overall shape of the torso. The middle tones of burnt umber were added in between although some were allowed to overlap the yellow ochre patches, thus creating a third, unifying tone. At all times, the brushes were kept fully loaded, and the washes were soft and fluid.

Adding deeper tones | **4**
Next, the darkest tones were added with a mix of the earthier hues of burnt umber and sepia tint. The basic shape and poise of the cat was described using the combination of light, medium and heavy tones, laid in soft fluid, washes which emulated the softness of the tabby's fur.

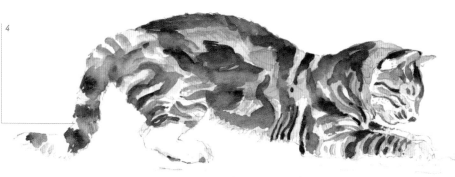

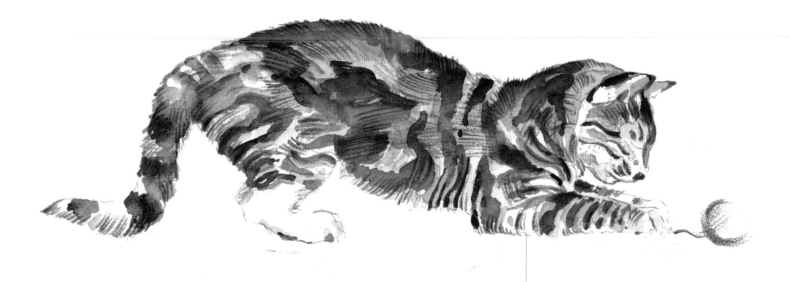

5 | **Directional strokes**
To illustrate the direction and texture of the cat's layered coat, water-soluble pencils were applied to the existing washes, where directional strokes could easily be made. Finer detail was also possible around the head and front paws using this method.

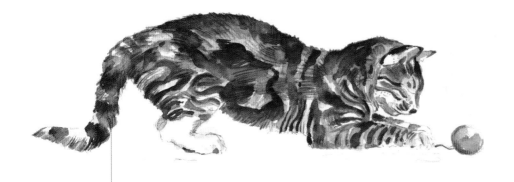

Techniques used

Hard and soft edges (*page 38*)
Line strokes (watercolour pencils) (*page 18*)
Scumbling (*page 123*)
Sketching (*page 104*)
Wash (*page 34*)
Wet-on-dry (*page 36*)

6 | *Adding texture*
To give the fur extra texture and body, clumps were selected and water was added to the soluble pencil strokes in selected areas, especially where there were folds in the skin, or deeper shadows, for example, between limb joints. Finally at this stage, deeper washes of burnt umber were mixed with a tiny amount of violet to create the very deepest shadows.

7 | *Finishing touches*
Tonal values were checked once more to ensure that the cat's body had a convincing and accurate, bodily description. A violet wash was dropped behind Abby and backruns were allowed to form beneath the pouncing limbs. The inclusion of this background has given the cat a base to stand on and a space to occupy. Finally, last details were added to face and body – the red of the ball was strengthened to give it more prominence and focus, and rapid water-soluble pencil strokes were scribbled with energy across the violet background to heighten the sense of movement and break up the flatness. Just a few directed marks was enough to bring this study to a successful conclusion, without overdoing it.

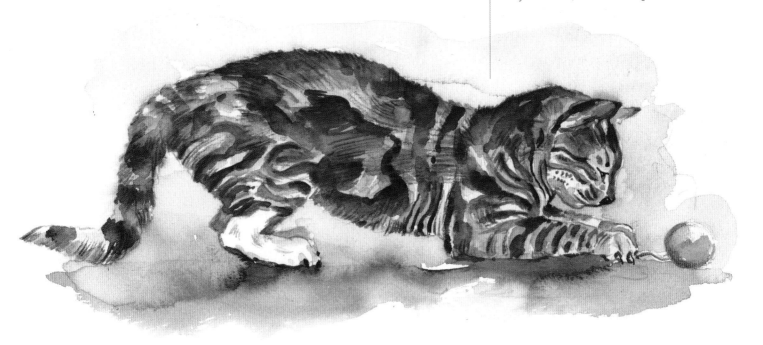

Creating texture

Winter Trees

Every visit into the countryside is a unique, sensory experience. The fall of light across fields and hillsides, dappled shade through thick canopies of foliage, and the changing colours of plants and flowers through the different seasons all create particular atmospheres and evoke certain moods. The harsh realities of winter are especially stimulating and definitely worth investigating, although weather conditions may only allow sufficient time outside to make rapid sketches. Twisting boughs, rough, pitted bark, partial snow-covered shrubs and dramatic wind-blown skies seen through the copse all express a stark mood when interpreted through a range of techniques covered in the earlier section of this book. This is the ideal studio project for those bleak winter months and allows you to expand your repertoire of textures and marks in readiness for sketching sojourns in the warmer months.

Ultramarine

Payne's grey

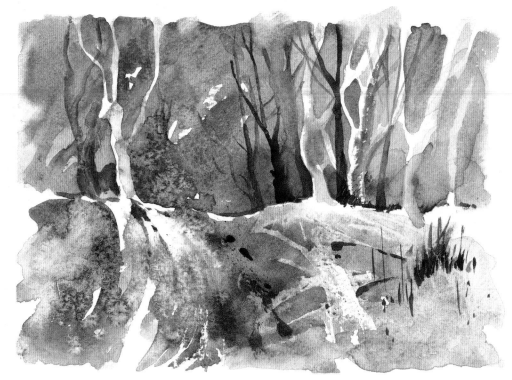

As my starting point, I made a rapid pencil sketch of the tree scene, loosely shaded with light, medium and dark tones, which is all the information necessary to begin the composition. It is fine to use a camera to help you remember what you saw, but do not rely on the detail that it will provide.

Like so many effective watercolour projects, this one is poignant in its simplicity. The successful capturing of the melancholy mood is due to the limited palette of just two colours, ultramarine and Payne's grey. There is a sense of loneliness and uncertainty here as the viewer is drawn into the scene by the curving pathway, which fades into the distant horizon. This compositional device is pivotal in making the picture work, as are the slender rows of bare, light and dark contrasting trees.

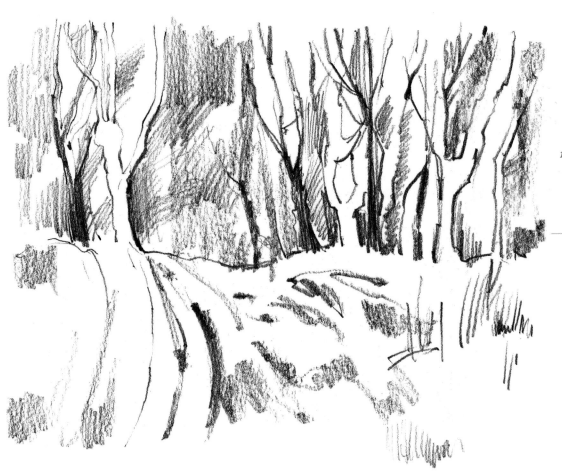

1 | *Initial pencil sketch*
First light HB pencil was used to sketch out the shaded areas.

Laying the first washes | 2

Reserving the whites is very important at this stage and will assist the contrast of light against dark when other shadowy trees are added. Drop the wash into the sky and gently guide the brush around the pencil marks denoting trees. Resist painting back over the edges to tighten the definition of the trunks and branches, rather enjoy the free flow of the paint and worry about refining later. As a fresh wash of deeper blue is dropped into an earlier drier one, it spreads and dislodges some of the pigment particles beneath. These collect at the edge of the wash as it dries creating a pale stain of colour with a darker, crinkled edge. Unpredictable, these backruns are perfect for representing the amorphous shape of a cloud or simply providing a mottled, textured background.

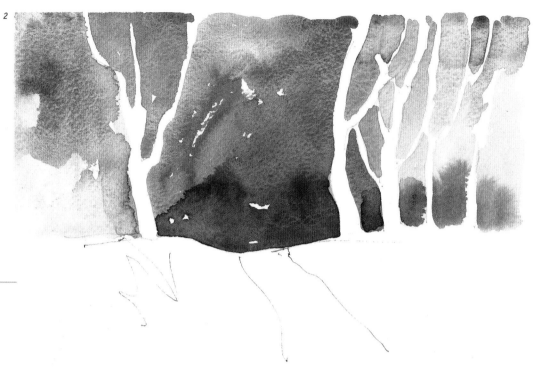

Painting the trees | 3

This intermediate stage shows how the interplay of light against dark trees was derived. The pencil lines served as a guide for the brush to flow around the 'white trees', thereby 'reserving' their shape. The darker trees were painted in between using Payne's grey with a no. 4 round sable brush. All the other detail was worked in layers thereafter.

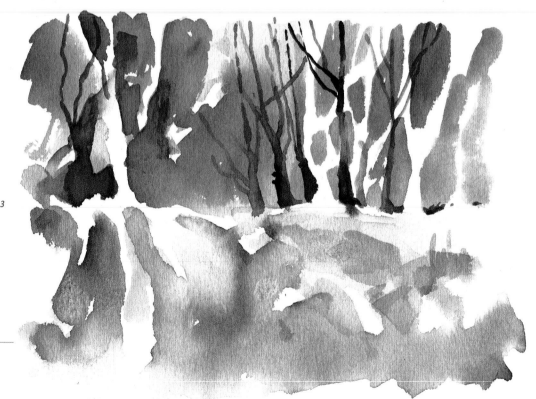

128

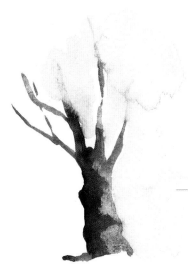

4 | Lifting out

This conventional technique – gently dabbing with a sponge, piece of kitchen towel or dry brush to remove wet paint – is an essential complement to the wilder ones. Here it is simply used to add a soft, diffuse light down one side of the trunks and branches to give them a sense of form and prevent them looking overly flat.

7 | Wax resist and clingfilm

The path and bank in the foreground are rubbed with a wax candle. When a wash of colour is laid over the wax, the paint is repelled by it and a broken surface emerges (see pages 58–59). The masked-out lines next to the resist are created by pressing crumpled clingfilm onto the paint while still wet. This plastic skin disperses the colour where it clings. When gently removed, it leaves clean-edged, spidery, white shapes.

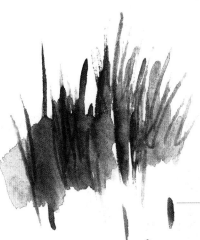

5 | Dry-brush and surface etching

The coarse grass sticking up through the snow is achieved in two ways. Firstly, with a small, round bristle brush, swiftly work upward strokes with very dry paint. Secondly, drop a full load of pigment into the area to give the clump more density, then, using the tip of the brush handle, etch firmly into the wet surface of the paper to create sharper grassy marks. The indents will fill with the wet paint and darken down immediately.

8 | Spatter

A final unifying texture to break up the flatness of snow is added by flicking the brush with your thumb. Wherever the paint lands it must remain.

6 | Salt (on damp wash)

The overall impression of weather and weathering is heightened with the use of common household salt. When sprinkled onto a damp wash, the grains immediately soak up the moisture from the paper while repelling the pigment, creating a granular area of tiny white patches. It is essential to judge the readiness of the wash for this treatment: if either too wet or too dry, the salt will not work.

Techniques used

Backruns (*page 47*)
Broken wash (*page 34*)
Clingfilm (*page 53*)
Dry-brush (*page 48*)
Hard edge (*page 38*)
Lifting out (*page 41*)
Reserving (*page 40*)
Sketching (*page 104*)
Spatter (*page 50*)
Wax resist (*page 58*)
Wet-in-wet (*page 37*)
Wet-on-dry (*page 36*)

Seascape

Sunset on the Water

The sea is never still. The hypnotic ebb and flow of tides, crashing waves, or gentle lapping of the shoreline ensure that there is always a visual problem waiting to be solved in the study of seascapes. In answering the problem, you will realize, as in so many other subjects, that there is no definitive way to describe the sea or its immediate environment, you must record it as you find it, in the way that seems most appropriate, and enjoy the total assault on the senses.

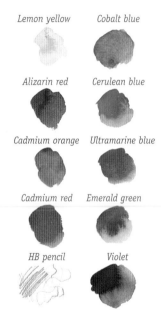

Lemon yellow *Cobalt blue*

Alizarin red *Cerulean blue*

Cadmium orange *Ultramarine blue*

Cadmium red *Emerald green*

HB pencil *Violet*

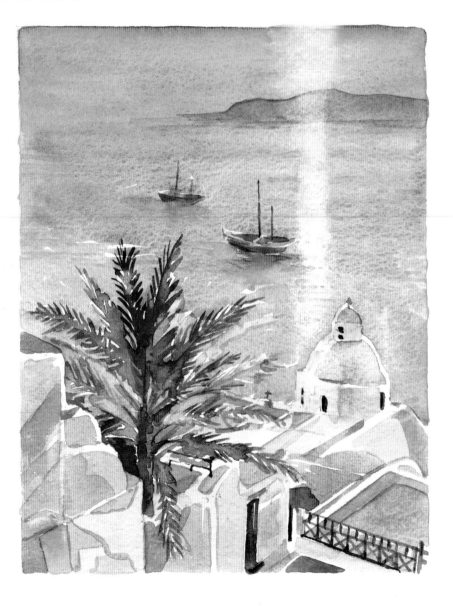

The sea is also a great reflector. It can provide the mirror-image of a subject, twisting and shimmering upon its surface, or reflect the light of the day as transmitted through clear sky or clouds. How different the colour of the sea can appear from one day to the next depending on the weather, and the openness of the ocean provides the perfect backdrop for glorious sunsets or spectacular storms.

It is the openness and awareness of space that I have chosen to emphasize in my study of a calm sea at sunset. My decision to paint this horizontal subject in a vertical way was deliberate; I was influenced by Japanese painting, in which elements higher up on the flat picture plane are interpreted as being further away. The simplicity of the whole scene, its calmness and the way that pure colour played upon the flat surfaces of buildings, was the major intent. A central focus was provided by the solid, upright palm, its fronds cascading upward and outward, leading your eye to the fishing boats, just offshore. A familiar image, it was a joy to use some of the more traditional techniques outlined in this book, and by the end of the painting I had visited a beautiful place in my brooding imagination.

Techniques used

Graded wash (*page 34*)
Hard edge (*page 38*)
Lifting out (*page 41*)
Reserving (*page 40*)
Sketching (*page 104*)
Wash (*page 34*)
Wet-in-wet (*page 37*)
Wet-on-dry (*page 36*)

1 | *Initial pencil sketch*
Having stretched a piece of A3, NOT surface watercolour paper (140lb/300gsm), I sketched lightly in HB pencil, the main foreground building shapes, background island and middle ground boats.

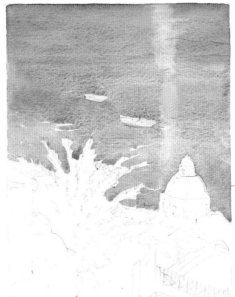

2 | *Laying washes for the sea and sky*
A graded wash of alizarin crimson fading into cadmium orange was dropped into the sky and sea areas using a medium wash brush, controlled around the outline edge of the church and palm tree. The orange, being the lightest colour, was laid down first with the board tilted upside down, so that the colour ran towards the centre of the sea. The crimson was floated from the top of the sky with the board now tilted the correct way up and the colours blended wet-into-wet, smoothly. The reflected light of the setting sun was created by lifting the colour out with a natural sponge in a vertical line from the top of the sky to the dome roof.

3 | Giving form to the buildings

The shadows cast on the village buildings by the low, fading sun were a warm, intense, watery blue, created by a mix of cobalt blue and violet. I tinted the dome and roofs with the blend, remembering to leave whites for highlights and this colour was also used to suggest the distantly, ethereal island, where it naturally changed to a warm mauve when laid over the orange.

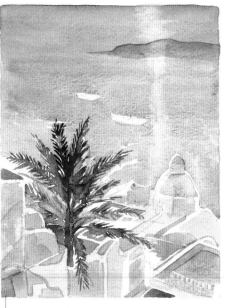

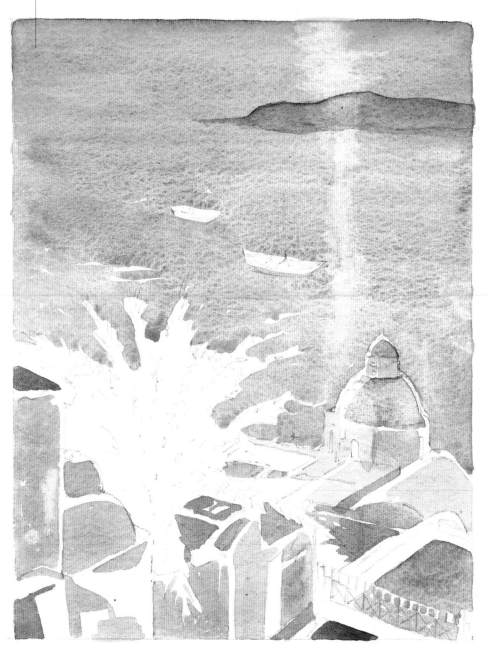

4 | Outlining the tree and overlaying washes

The primary focus of this seascape is the large, fronded palm, growing up out of a roof garden. Compositionally off-centred, its strong colouring of emerald green and cerulean blue with watery fusions of cadmium red and lemon yellow, draws the viewer right into the foreground, leading the eye up to the boats and beyond. I brushed the palm into the scene with definite strokes of a no. 8 round sable brush, detailing individual leaves with a no.4. The solidity of the trunk was achieved with strong, wet-in-wet washes, and structure was added with wet on dry strokes. Pale washes of cadmium orange and alizarin crimson were laid over the surfaces of some of the buildings; the echoes of the sky and sea helped to relate them more fully to the overall light of the setting. Highlights were still left as bare, white paper.

5 **Painting the boats**

The boats were painted next. Their lonely presence exaggerates the middle ground and emphasizes the breadth of the still ocean. No new hues were applied to the hulks of the boats, just cerulean blue mixed with cadmium red, which produced a warm grey, but ultramarine blue, alizarin crimson and a little violet produced stronger shadows rippling directly beneath the boats.

Adding depth and finishing touches

To gain a real sense of depth in the foreground village, I stroked in the dark shadow areas inside windows and doors, and added the intricate railings. Other shadow areas were also darkened with a mixture of violet and ultramarine blue. Finally, I scanned my eye over the entirety of the painting, making sure that no minor details had been missed, and that edges were crisp and neatly finished, especially where object meets surface, for example, the gaps between palm leaves and the sea. These were smoothed and blended with a no. 2 round sable brush.

Series painting

View from the Château

A summer holiday in the celebrated wine region of Charente in southwest France provided the perfect location for an exploration of colour and light. As the warming copper sun streamed through the window of Château Charras, the waking landscape of rolling hills and dense forests demanded to be captured in a series of constantly changing colour snapshots. With Monet's inspirational haystack series as my guide, my excitement spilled over into a rich and varied palette as I sought to reflect the steady variations of light and weather that passed before me. As my confidence grew so did my curiosity, ending with night sittings of the same scene.

These six paintings of the French landscape, all viewed from the same position at various times of the day and over a number of days, clearly show how changing weather and light affects colour, tone and definition. Focusing on a single theme in this way gives pictures extra meaning and greater impact when seen together as a series. The discipline of returning for sustained periods of time to the same subject also strengthens the ability to paint from life.

Rolling mist

As mists roll through the picture planes, new details come into and go out of focus, and a decision must be taken to freeze-frame the scene at a chosen moment. A milky palette of unsaturated yellow ochre and lemon yellow washes gives a subtle, low-key glow throughout, forming what is known as a 'coloured neutral', which heightens the effect of the stronger hues.

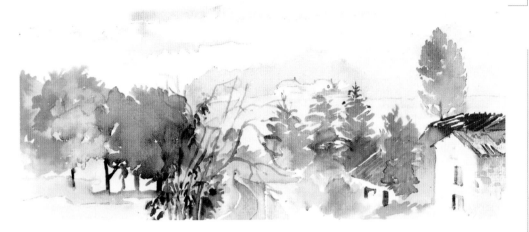

Rain

Painting in the rain is a wonderful technique that lets the water droplets do all the work. Here neutral tint mixed with a thin wash of yellow ochre conveys the heaviness of stacking storm clouds. The intense contrast between areas of unpainted white paper and the painted clouds heightens the drama, but this whole effect is subtly calmed as the spatters of rain soak into luminous pools on the paper. The blending of high-key and low-key palettes creates a tension between the calm and the storm.

Sunrise

On a clear day the summer sun rises quickly in the sky and brings with it a palette of bright, saturated hues known as high-key colours (see page 30). The dense passages of alizarin crimson, cerulean blue and viridian green in the trees evoke a feeling of strong light against the cadmium red and cadmium yellow reflected on the ground.

Techniques used

Backruns *(page 47)*
Graded wash *(page 35)*
Hard edge *(page 38)*
Lifting out *(page 41)*
Masking *(page 56)*
Rain painting *(page 102)*
Sketching *(page104)*
Surface etching *(page 116)*
Salt on damp wash *(page 116)*
Wash *(page 34)*
Wet-in-wet *(page 37)*
Wet-on-dry *(page 36)*

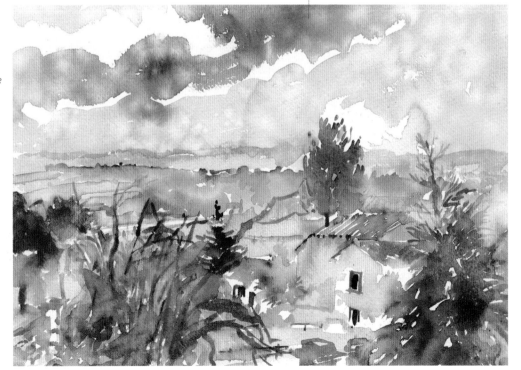

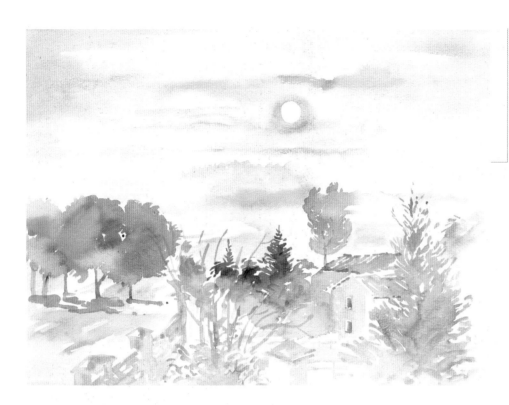

Sun through mist

The orange of the sun predominates across the whole composition. The sun itself is deliberately left as untinted paper, which reflects light strongly and which, seen against the less reflective painted areas, gives the illusion of powerful luminosity. A drier brush is used than in the other studies, giving greater overall control of the application of colour and creating a calm and tranquil atmosphere.

TIP

Always test the suitability of masking fluid to the type of paper you have selected on off-cuts or on an inconspicuous edge or corner of the paper.

Early evening

A broad, flat wash brush is used to lay washes of cerulean blue in the sky. The pressure is released during the drag of the brush to leave sparkling passages of unpainted paper to represent wispy clouds. The white walls, reflecting the evening light, are left similarly pigment-free. Violet and ultramarine blue give the middle-ground trees a moody presence, in contrast to the cadmium yellow accents glowing from the windows. The general lack of detail reinforces the sense of the dusky light of evening.

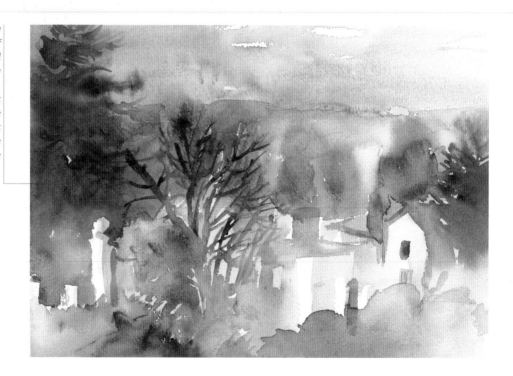

TIP

Overdone watercolours that have
lost their luminosity can be saved.
Lift heaviness from paint marks
with a clean brush and fresh water.
Flood the area with the water and
gently dab the paper with a soft
tissue or piece of cotton wool.
Repeat this task until you have
achieved the desired density.

Night
*The riskiest of all the watercolours in this series, this
study attempts to evoke the emergence of night.
Before any pigment is added to the paper, masking
fluid is used to draw the distant lights, windows,
rooftop and branches. The paper is then flooded with
cerulean and ultramarine blues and sepia. Once the
masking fluid is removed, cadmium yellow is added to
the previously masked areas. Note the backrun in the
top half of the composition, which has been
deliberately caused to evoke a brooding sky.*

Glossary

Absorbency

The extent to which a paper will soak up paint. This is controlled by a gelatinous substance known as size.

Adjacent colours

Those colours closest to each other on the colour wheel, or immediately next to each other in a painting.

Aerial perspective

The creation of the illusion of space in a painting using the colour and tone perceived through atmospheric conditions. As objects recede into the distance they appear lighter in tone and more blue.

Artists' Quality paint

The very best quality paints with purest pigment content and strong colour.

Binder

The substance that holds pigment particles together to form paint. In watercolour and gouache the binder is the water-soluble gum arabic, whereas in oil paint it is linseed oil.

Bleeding

Where the pigment particles are carried by the flow of water beyond the mark made by the brush.

Blending

The soft, gradual transition from one tone or colour to another.

Blocking in

The application of broad areas of paint which form the base of a painting. Masses of light and dark shapes can be freely brushed to help establish a composition.

Body colour

Another name for opaque watercolour and its accompanying techniques. Also known as gouache.

Chroma

The saturation or intensity of a colour.

Chromatic

Belonging to a range of colours.

Cockling

The buckling of unstretched paper when it is wetted.

Cold-pressed (C.P.)

A technical term given to paper that has been manufactured through rollers at a cool temperature. Its surface is not as smooth as 'Hot-pressed', or as textured as 'Rough' paper. It is also known as NOT.

Coloured Neutral

A subtle, unsaturated colour, produced by mixing a primary and secondary colour in unequal amounts.

Complementary colour

One of a pair of maximum contrasting colours that sit opposite one another on the colour wheel. The complementary of a primary colour is a mixture of the two remaining primaries.

Composition

The arrangement of elements such as colour, light and shade, shapes, lines and stresses are all coherently designed onto the paper to create composition in the picture.

Cool colour

Blue and green are generally described as cool. Under atmospheric conditions, distant colours tend to appear as cooler colours and recede.

Dry brush

A technique giving a broken, feathery texture when a dryish brush is loaded with pigment and dragged across the surface grain of the paper.

Earth colours

Colours made from naturally found clays, iron oxides and other minerals. The ranges are ochres, siennas and umbers.

Ferrule

The tapered, cylindrical metal collar that fits around the handle and holds the brush hairs in place.

Flat wash

Uniform tone achieved by laying a wash over a broad area using a large brush.

Focal point

The main area of visual interest in a picture.

Fugitive

Colours that are not light-fast and will fade over time.

Glaze

Primarily an oil term, but occasionally used in watercolour to describe an overall wash in a single colour.

Gouache

An opaque watercolour paint. Sometimes referred to as designer or poster colour, it can be laid in transparent washes or painted as solid light over dark colours.

Graded wash

A wash in which tones move smoothly from light to dark or dark to light.

Grain

The texture of the surface of watercolour paper.

Granulation

A mottled effect caused by naturally coarse pigmentation in certain colours, as it rests in the dips and troughs of the paper surface.

Gum arabic

Gum extracted from the sap of the African acacia tree, and used as a binder for watercolour paints.

High-key colour

Colour that is saturated and brilliant.

Highlight

The lightest tone in painting, represented in watercolour by the bare, unpainted whiteness of the paper, or added flecks of body colour.

Hot Pressed (H.P.)

A very smooth paper made by being pressed through hot rollers during its manufacture.

Hue

Another name for a spectral colour such as red or blue.

Impasto

A thick application of paint, often straight from the tube.

Lifting out

Technique used to alter colour or create highlights by removing colour with a cloth, sponge or brush.

Light-fastness

The permanence of a colour.

Linear perspective

A means by which illusion of depth can be created using converging lines and vanishing points.

Local colour

The intrinsic colour of an object unaffected by external conditions of light and atmosphere.

Low-key colour

The opposite of high-key colour, where hues are muted or unsaturated.

Masking fluid

A white or creamy-yellow solution of liquid latex used to mask out particular areas of a painting. It dries to form a rubber skin that can be rubbed away gently with fingertips when masking has been achieved.

Masking out

The technique of using masking fluid or other material to protect areas of paper while adding paint.

Masking tape

A low-tack, paper tape used for masking or to temporarily affix a sheet of paper to a drawing board. It peels off without damaging the surface of the paper.

Medium

A word with several meanings, it can describe the material used in a painting, the material used to keep pigment together, or any other material added to watercolour that in some way changes its properties and the way it behaves.

Monochrome/monochromatic

A painting or drawing made in tones of a single colour.

Negative space

The spaces between objects. These can be viewed as positive abstract shapes in a composition.

Neutral colour

Colours created by mixing unequal amounts of complementary colours, which cancel out to form a dull, neutral colour.

NOT

Cold-pressed paper with a fine, grainy surface or one that is semi-rough.

Opaque

Non-transparent medium.

Optical mixing

A new colour achieved by placing two colours beside each other, rather than mixing them in a palette. This is most effectively perceived when the colours are viewed from a distance and appear to the eye as a single colour.

Overlaying washes

The technique of painting one wash on top of another to gradually build up depths of tone or colour.

Oxgall

A wetting medium that assists the flow of paint on a surface.

Palette

A shallow, tray-like container, normally made of plastic or porcelain, into which colours are mixed. Most palettes have multiple wells incorporated in the tray for mixing a number of colours simultaneously. The reference to an 'artist's palette' also indicates their personal choice of colours.

Permanent colours

Pigments that are light-fast and will not fade are known as permanent.

Perspective

Representing a three-dimensional object on a two-dimensional surface requires the use of perspective. Linear perspective makes objects appear smaller as they get further away and this is measured and drawn using a geometric system of converging lines. Aerial perspective creates the illusion of depth by using paler cooler colours in the distance and warmer, brighter ones in the foreground.

Pigment

Coloured particles, usually finely ground to a powder, which form the basic component of all types of paint and drawing materials.

Primary colours

These are the three colours – red, yellow and blue – that cannot be made by mixing other colours. In various combinations they form the basis of all other colours.

Receding colour

When colours such as pale blue are perceived as being distant from the viewer, they are known to recede.

Resist

This is the process of preventing contact between paint and paper using an oily or waxy film, which deposits a protective coating. Materials such as candle, wax crayon and oil pastel naturally adhere to the paper surface and repel or 'resist' water. Non-waxed areas receive the paint, resulting in interesting broken colour effects.

Rough

Papers with a highly textured surface, and often hand made.

Sable

Tail hairs of the mink, used to make soft, fine watercolour brushes.

Saturation

The saturation of a colour denotes its colour intensity. Colours are vivid and strong if saturated, and dull and pale if unsaturated.

Scratching out

The removal of pigment from the surface with a sharp blade to reveal an under-layer of paper is called scratching out. It can also be an effective way of creating small highlights.

Scumbling

This is the application of a loose, but dry watercolour base using broad strokes to give the painting an underlying tint or texture. Many artists allow this base to show through successive layers.

Secondary colours

These are made up from the pairing of two primaries: yellow and blue make green or red and yellow make orange.

S'graffito

Dried paint is scratched off a painted surface with a knife to produce a textured effect.

Shade

Any colour mixed with a darker colour, e.g. black.

Size

The gelatinous substance applied to paper, which controls its hardness and absorbency – usually by reducing it.

Spatter

The technique of flicking paint to create a mottled, textural effect. An old toothbrush or stiff, dry paintbrush can be loaded with colour, and a finger then run through the bristles to cause pigment to disperse in a fine spray.

Sponging out

Using a natural sponge or paper towels, this technique soaks up wet paint, thereby removing lightening or removing it from the paper. It can be used to correct mistakes or to produce subtle effects.

Stains

A dye or pigment that is not easily lifted, or resists being washed off the paper surface, has a strong staining power.

Stippling

This involves painting areas full of small dots, applied with the tip of the brush.

Stretched paper

The process of allowing paper fibres to expand and contract so as to avoid buckling when wet paint is applied. The paper is wetted, affixed to a board and allowed to fully dry naturally, before being used.

Support

The surface on which you paint; most commonly for watercolour painters this is paper.

Surface

The texture of the paper, e.g. Rough, Hot-pressed (smooth finish), and NOT, literally Not hot-pressed, or semi-rough.

Tertiary colours

Colours that contain all three primaries, created by mixing a primary with its adjacent secondary colour. Coloured neutrals appear when any two colours are mixed together.

Tint

Any colour mixed with white.

Tone

The lightness or darkness of a colour, especially where light falls dramatically on an object.

Tooth

The ability of a surface to hold paint in its grain.

Unsaturated colour

Mixing a pure, saturated colour with another colour forms either a tint or shade, and this is unsaturated.

Variegated wash

Two colours laid in broad, wet passages meet-up and blend smoothly into a wash, known as a variegated wash.

Viewfinder

This is made from two L-shaped pieces of card, whose aperture can be altered to become smaller if necessary. Paperclips hold it together and the rectangular parameters help to crop out unnecessary elements.

Warm colours

Oranges and reds are described as warm colours, and appear to advance towards the foreground of a picture.

Wet-in wet

This is wet colour worked into another wet colour on the support.

Wet-on-dry

The application of wet brushwork onto a dry surface.

Index

Author's Acknowledgements

Dedicated to Tilly, the brightest colour in my palette.

The author would like to thank Polly and the team at Cassell Illustrated for agreeing to take me on! Thank you John and Katie at Essential Works for running the project so smoothly and efficiently, and to Barbara and Paul for designing the book with such flair and professionalism. Special thanks to Diana, my editor, for her vital role in structuring the sections, and for meticulously checking the content and making it fit. Grateful thanks must go to Caitlin Davies for agreeing to lend her portrait for the masterclass.

Eternal thanks to Susanne, my loving and devoted wife and personal manager who has kept me on course throughout, and to our children Tilly and Noah, for their wonderful expression of life - a constant source of inspiration.

My final thanks must go to you, for buying this book.

Picture credits

Sotheby's Picture Library pages 8, 9, 10 and 11 (top left), Powerstock pages 7 and 11 (bottom right).
Ohne Titel (Aquarelle Mouvementee) 1923 by Wassily Kandinsky © ADAGP, Paris and DACS, London 2003.
Special photography by James McMillan pages 22–23.

For Essential Works

Design	Barbara Saulini, Paul Collins and Liz Brown
Project Editor	Diana Craig
Editor	Barbara Dixon
Index	Ian Crane